A celebration of the National Art Collections Fund

National Art Collecting

Researched and compiled by ALYSON WILSON

National Art Collections Fund
in association with Laurence King

Published 1993 by Laurence King Publishing

A catalogue record of this book is available from the British Library.

ISBN 1 85669 046 6

Designed by Derek Birdsall, RDI
Production supervision by Martin Lee/Omnific
Printed in England by Balding + Mansell

Front cover:
John Atkinson Grimshaw, FIAMELLA, 1883
(see pages 116–17)
Reproduced by kind permission of Bradford Art Galleries and Museums

Contents

Acknowledgements

The National Art Collections Fund would like to thank the Directors of the museums and galleries concerned for permission to include works in this publication, and for kindly agreeing to display special labels beside the works during the autumn of 1993. We are also grateful to the keepers, curators and staff of the appropriate departments for their help in providing up-to-date information on the works, supplying photographs and checking copy. It is with particular pleasure that we acknowledge the generosity of The John Ellerman Foundation which has made this book possible.

I am grateful to family, friends and colleagues – too numerous to list – for their help, support and encouragement. I owe special thanks to all within the National Art Collections Fund. The original idea for this book came from Marina Vaizey, as did the invitation to me to develop it. The enthusiasm of the former Director, Sir Peter Wakefield, launched the project and that of his successor, David Barrie, brought it to fruition. But above all, I am deeply indebted to Robert McPherson, who has so ably assisted me throughout. Without his wide-ranging knowledge of the Fund and of museums and galleries, the selection of works, the securing of permissions and photographs, and many other tasks would have been immeasurably more arduous. The text has been patiently and ably edited by Jacky Colliss Harvey. Derek Birdsall, with his inimitable flair and sensitivity, has presented the material with an elegance truly worthy of the works of art. I thank them both wholeheartedly.

ALYSON WILSON

Works are arranged in chronological order of acquisition by the museums and galleries.

Quotations are transcribed from the cited texts without amendment.

Dimensions are given in centimetres, height before width before depth.

Introduction

Since 1903 the National Art Collections Fund has been helping museums and galleries acquire works of art in order to heighten the enjoyment of visitors to their collections. By giving financial aid and by guiding and handling bequests we have helped the acquisition of many thousand works of art. In this book we give a flavour of our achievement by illustrating ninety selected works. These are by no means all the stars in our galaxy – although they include some of the stars – nor do they represent every category of art or every gallery that we have helped. So, why only ninety? Because we are ninety years old this year.

The intention is to encourage the reader to explore the many museums and galleries in the United Kingdom by revealing some of the treasures to be found in them. To this end, special labels with quotations from *National Art Collecting* will be shown beside the selected works for several months after publication.

Because we have selected works which are, with one or two exceptions, on permanent public display, the anthology excludes works on paper and most textiles which, for reasons of conservation, cannot be permanently displayed. It also excludes coins, jewellery and most decorative arts which, because of the way they are shown, cannot be specially labelled or easily found and identified.

The works in the book are arranged in chronological order of acquisition. The selection thus acts not only as a history of the Fund, but also as a history of taste in collecting. In the early days the Fund often purchased works of art with the help of members' donations and gave them to museums – usually national rather than local collections. Times – and prices – have changed and there are now other sources of funding, so that we now normally only provide a percentage of the purchase price of a work which a museum or gallery may wish to acquire. However, the scale of our activity has enormously increased. We now respond to requests for financial help from all over the United Kingdom.

In addition to direct financial help, donations and bequests through the Fund have always been important. These have ranged from individual items, sometimes donated to commemorate a person or an event, to bequests on the scale of Ernest Cook's collection of nearly two hundred works of art, distributed by the Fund in 1955 to many different galleries, or Charles Kearley's choice collection of twentieth-century paintings, bequeathed in 1989 through the Fund to his local gallery in Chichester, Pallant House.

We hope that the words accompanying the illustrations will illuminate, entertain and stimulate the reader's interest in the artists and their work. Each quotation is intended to add to the appreciation of the work, whether it is Vasari commenting on Titian's late style exactly as we might today, Rossetti writing to his mother about the price of roses (surprisingly high in today's terms), Charles Dickens describing his first view of Florence or Baron Denon reporting that Napoleon proposed to 'possess himself' of *The Warwick Vase* as soon as he had conquered England. We hope furthermore that the reader will be inspired to visit galleries and museums – not only the necessarily restricted number from which we have been able to include works, but many more of the rich collections all over the country that the Fund has helped to build up over the past ninety years. We hope that members will take pride in their contribution to the achievement of the Fund, and that those who are not yet members may be encouraged to join us in our valuable work.

We are greatly indebted to The John Ellerman Foundation for their generous support of this publication.

Sir Nicholas Goodison
Chairman
National Art Collections Fund

'Why should not I call my works "symphonies", "arrangements", "harmonies", and "nocturnes"?...

As music is the poetry of sound, so is painting the poetry of sight, and the subject-matter has nothing to do with harmony of sound or of colour.

The great musicians knew this. Beethoven and the rest wrote music – simply music; symphony in this key, concerto or sonata in that.

...Art... should stand alone, and appeal to the artistic sense of eye or ear, without confounding this with emotions entirely foreign to it, as devotion, pity, love, patriotism, and the like. All these have no kind of concern with it, and that is why I insist on calling my works "arrangements" and "harmonies."'

James Abbott McNeill Whistler, *The World*, 22 May 1878

Tate Gallery, London
Acquired in 1905

NOCTURNE IN BLUE AND GOLD: OLD BATTERSEA BRIDGE, *c.* 1872–5
Oil on canvas, 67.9 × 50.8
James Abbott McNeill Whistler (1834–1903)

This was one of the Nocturnes exhibited at the Grosvenor Gallery in 1877, and produced in court in the libel action brought by the artist following Ruskin's virulent criticism. The painting was the first modern work acquired by the Fund, in 1905 – only two years after the death of the artist, when his work still represented advanced rather than popular taste. It was given by the Fund to The National Gallery and exhibited at Trafalgar Square for a while, before being transferred to the National Gallery of British Art, Millbank (now the Tate Gallery). It is in its original frame, decorated by Whistler with his butterfly signature.

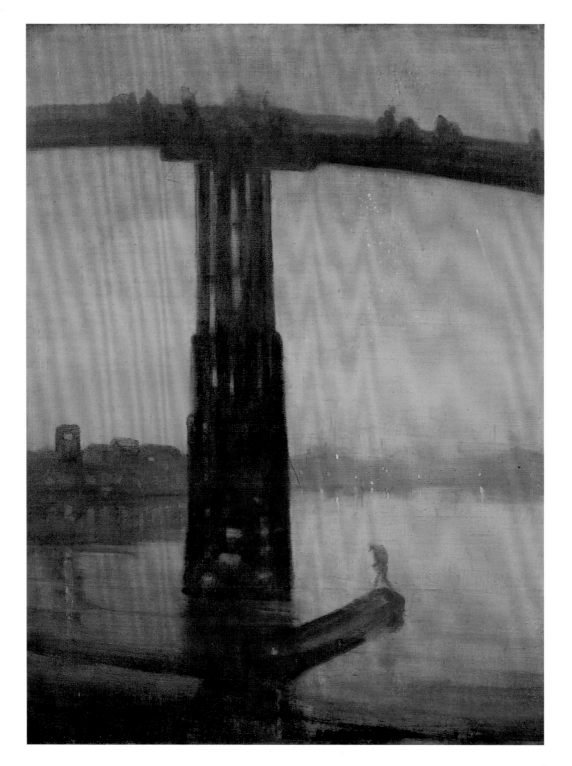

'At the Duke of Alba's is to be seen… a charming Venus, by Velasquez, lying half reclined with her back to the spectator, and her face reflected in a mirror she holds in her hand.'

Henry Swinburne, *Travels through Spain in the Years 1775 and 1776*, letter of 4 June 1776

'This Spanish Venus is… not that Aphrodite at all whom lovers tremulously invoke in worship and in awe. She is rather the Goddess of Youth and Health, the embodiment of elastic strength and vitality – of the perfection of Womanhood at the moment when it passes from the bud into the flower.'

Anonymous 'eminent' critic, quoted in *The Times*, 11 March 1914

The National Gallery, London
Acquired in 1906

THE TOILET OF VENUS ('THE ROKEBY VENUS'), 1651
Oil on canvas, 122.5 × 177
Diego Velázquez (1599–1660)

Probably painted for the Marqués del Carpio during Velázquez's visit to Italy between 1649 and 1651 (such a subject would have met with the disapproval of the Inquisition in Spain at the time), this work was in collections in Spain and Italy before being brought to England by a dealer in 1813, and purchased by John Morritt of Rokeby Hall, Yorkshire, on the advice of Sir Thomas Lawrence. When the family decided to sell the painting in 1905, a public subscription was organised by the two-year-old National Art Collections Fund. The list of donors was headed by 'An Englishman', who gave £10,000, and concluded with 'A Young Student', whose contribution was 2 shillings. The purchase price of £45,000 was finally raised, and the painting bought from Agnews by the Fund, and presented to The National Gallery in 1906.

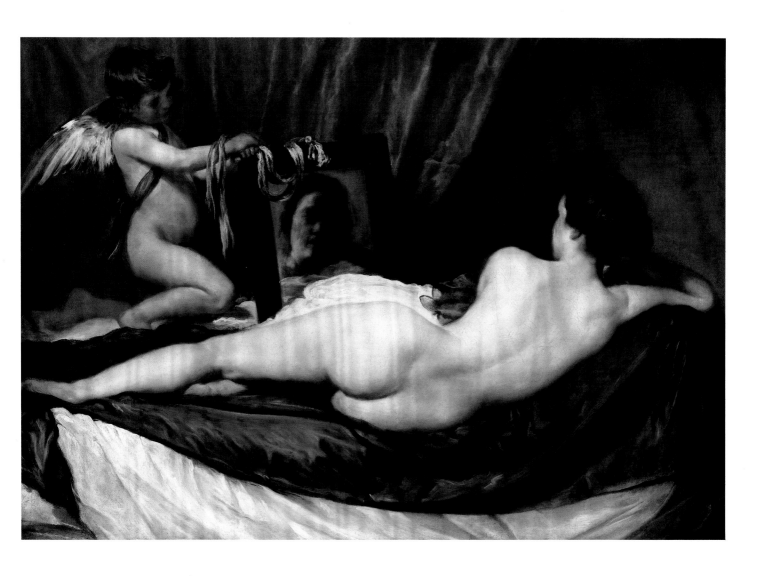

'Augustus was remarkably handsome and of very graceful gait even as an old man; but negligent of his personal appearance. He cared so little about his hair that, to save time, he would have two or three barbers working hurriedly on it together, and meanwhile read or write something, whether they were giving him a haircut or a shave.
He always wore so serene an expression, whether talking or in repose, that a Gallic chief once confessed to his compatriots: "When granted an audience with the Emperor during his passage across the Alps I would have carried out my plan of hurling him over a cliff had not the sight of that tranquil face softened my heart; so I desisted."'

Gaius Suetonius Tranquillus, *The Twelve Caesars, c.* AD 130

British Museum, London
Acquired in 1911

BRONZE HEAD FROM A STATUE OF AUGUSTUS, *c.* 27–25 BC
Bronze, 44.5 high

It has been estimated that the height of the complete statue must have been nearly 8 feet – considerably over life-size, since Suetonius tells us that Augustus was only 5 feet 7 inches tall. The statue was probably made in Egypt, and decapitated by tribesmen from Meroë, near Kabushia in the Sudan, who raided Roman forts in Egypt. They took the head back with them, to bury under the steps of their temple, in commemoration of successful raids. The head was discovered at Meroë by the Sudan Excavations Committee, who gave it to the British Museum in 1911 'in consideration of one thousand guineas towards the Committee's further excavations from the National Art Collections Fund'.

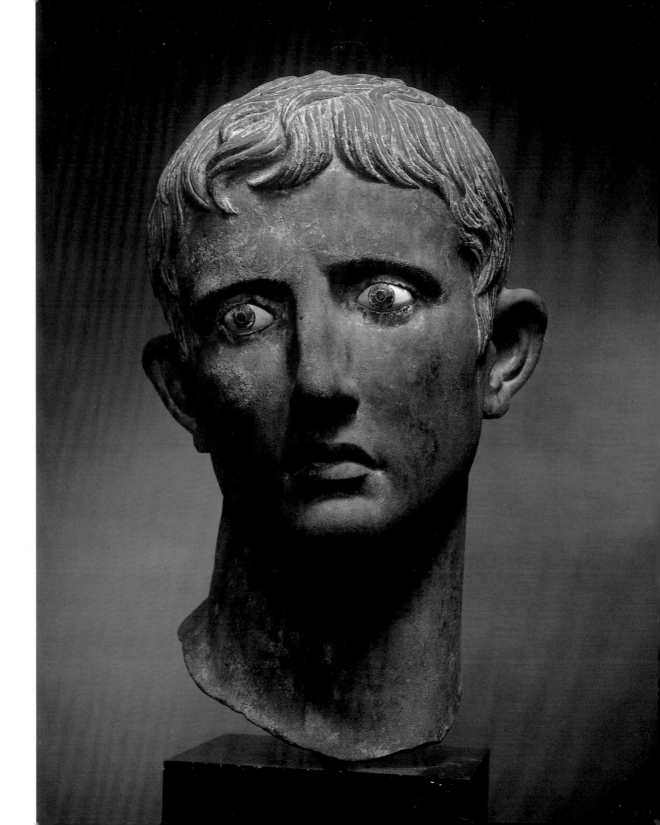

'In the Carmelite Church at Pisa, inside a chapel in the transept, there is a panel painting by Masaccio showing the Virgin and Child, with some little angels at her feet who are playing instruments and one of whom is sounding a lute and inclining his ear very attentively to listen to the music he is making.'

Giorgio Vasari, 'Masaccio', *Lives of the Artists*, 1568

The National Gallery, London
Acquired in 1916

THE VIRGIN AND CHILD, 1426
Tempera on poplar panel, 135.3 × 73
Masaccio (1401–27/9)

This is the central panel of a large altarpiece painted by Masaccio in 1426 for the chapel of San Giuliano in the church of Santa Maria del Carmine, Pisa. It was commissioned by a local notary, who had the patronal rights to the chapel. The altarpiece was broken up in the eighteenth century, and other parts are in museums in Berlin, Naples and Pisa. The purchase of this painting in 1916 by The National Gallery, with half the cost provided by the National Art Collections Fund, was a major triumph. Not only is it one of the few panel paintings by Masaccio to survive, but it is also his only documented work.

'And one shall say unto him, What are these Wounds in thine hands?
Then he shall answer, Those with which I was wounded in the house
of my friends.'

The Bible, Zachariah 13: 6 (quotation attached to the painting by Millais when it was
exhibited at the Royal Academy in 1850)

'Mr Millais' principal picture is, to speak plainly, revolting. The attempt
to associate the Holy Family with the meanest details of a carpenter's
shop, with no conceivable omission of misery, of dirt, of even disease,
all finished with the same loathsome minuteness, is disgusting.'

The Times, 1850

Tate Gallery, London
Acquired in 1921

CHRIST IN THE HOUSE OF HIS PARENTS ('THE CARPENTER'S SHOP'), 1849–50
Oil on canvas, 86.4 × 139.7
Sir John Everett Millais, Bt. (1829–96)

Millais' father, a carpenter, was the model for Joseph in this painting, and not only were
all the details fully discussed with him, but Millais is said to have worked on the canvas in
a carpenter's shop in London's Oxford Street. The painting contains complex allusions to
the life of Christ and Christian faith: these include Christ's death on the cross (nails and
wood), the Trinity (the triangular set-square), Baptism (St John holding a bowl of water)
and the Christian church (the flock of sheep). When the picture was exhibited at the
Royal Academy in 1850, reviewers were outraged, but it had already been sold before
the exhibition to a dealer who proudly pasted all the adverse critisicm on the back of
the painting. It was on loan to the Tate Gallery for ten years before its purchase in
1921, as a result of an appeal led by the National Art Collections Fund.

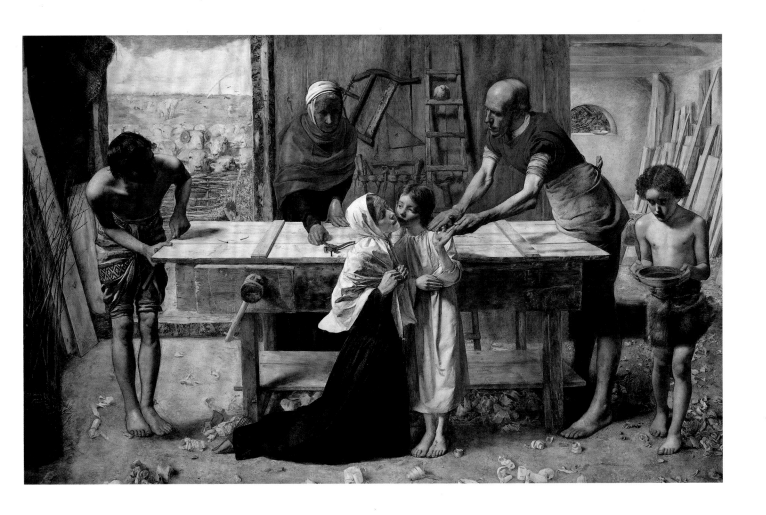

'JOHN OF THANET, a Monk and Chaunter of this Church, well vers'd in the Mathematicks; but especially skill'd in Musick. He set the Services and Offices for this Church to Musick, and wrote some Legends of Saints. He died in the year 1330, on the 6th of the Ides of April, in time of High Mass, being aged 92 Years and was buried in this Church.'

J. Dart, *The History and Antiquities of the Cathedral Church of Canterbury*, 1726

Victoria and Albert Museum, London
Acquired in 1921

JOHN OF THANET PANEL, 1300–20
Embroidered silk panel, 100 × 41

This silk panel, richly embroidered with silver-gilt and silver thread, coloured silks and small pearls, is a superb example of the medieval embroidery known as *opus anglicanum*. It is part of a religious vestment, probably a cope (the enveloping cloak worn mostly for processions), and the triangular void at the top would have been covered by a hood. John of Thanet is mentioned in the records of Canterbury Cathedral in 1315 – the date of an important inventory of the cathedral treasure. The panel was bought with the help of the Fund from St Dominic's Priory, Haverstock Hill, London, by the Victoria and Albert Museum in 1921, but its early history is not known.

'A little way to the southward, from the midst of a sandy hollow, rises the head of the Sphinx. Older than the Pyramids, older than history, the monster lies couchant like a watchdog, looking over to the east, as if for some dawn that has not yet risen.'

Amelia B. Edwards, *A Thousand Miles up the Nile*, 1877
(description of the Great Sphinx at Giza)

British Museum, London
Acquired in 1927

GNEISS SPHINX, *c.* 1795 BC
Stone, approx. 38.1 high

The sphinx, a symbol of power and vigilance in ancient Egypt, was represented as a lion with a human head. This example, from the Twelfth Dynasty, is inscribed to King Ammenemes IV, and the face, though damaged and reworked in Roman times, is the only surviving portrait of the king. The stylized treatment of the lion's mane, with its short locks, is characteristic of the period. The circular hole in the middle of the back may have been used to support a shade or flagpole. The work was purchased by the National Art Collections Fund in 1927 and presented to the British Museum.

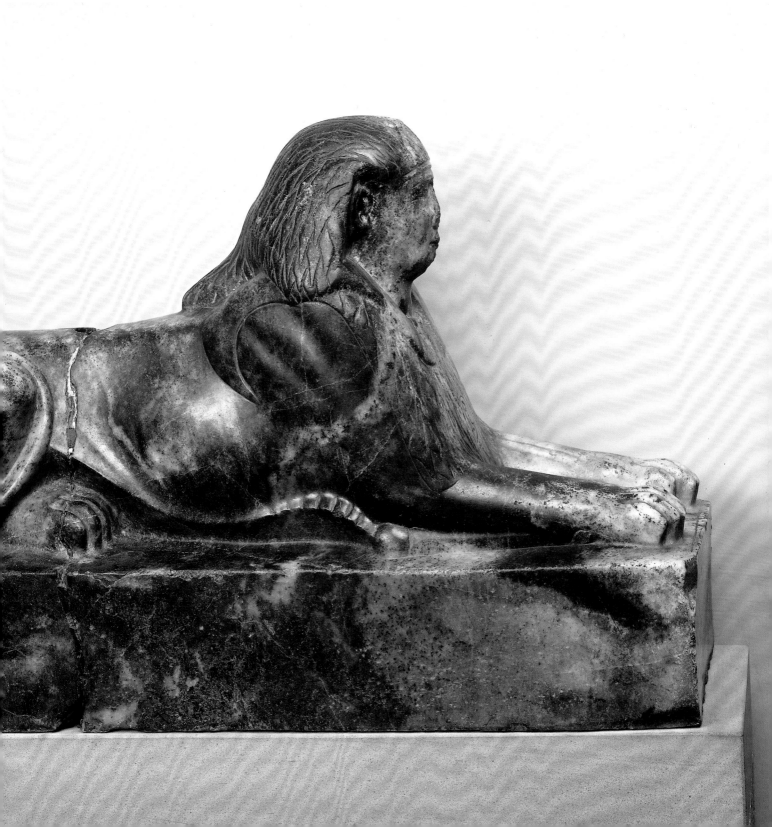

'With gazelles he ate the grass,
With the cattle he quenched his thirst
With flocks his heart rejoiced to drink.'

The Epic of Gilgamesh, c. 650 BC (Assyrian text)

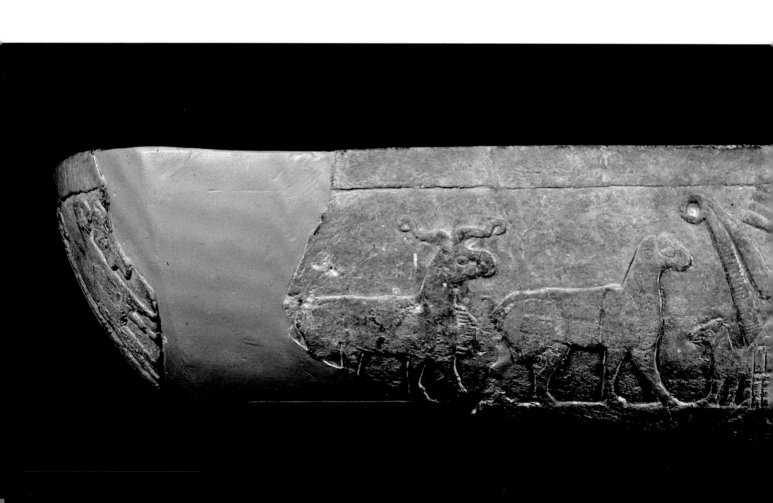

URUK TROUGH, *c.* 3300–3000 BC
Stone, 15.2 × 96.5 × 35.5

This stone trough, found at Uruk, is one of the earliest examples of formal religious art from Mesopotamia. It may have been used to water the temple flocks, although at an appropriate height for use as a trough, the relief decoration on the sides is not easily visible. It was, therefore, probably a cult object in the temple of Inanna, the supreme goddess of Uruk. The meaning of the carved scene is obscure, but the lambs emerging from a hut of plaited reeds may reflect the fecundity of the flocks under the protection of the goddess. The hut itself closely resembles the present-day dwellings of the Marsh Arabs. In response to a pressing request from the British Museum, the trough was purchased by the National Art Collections Fund and presented to the museum in 1928.

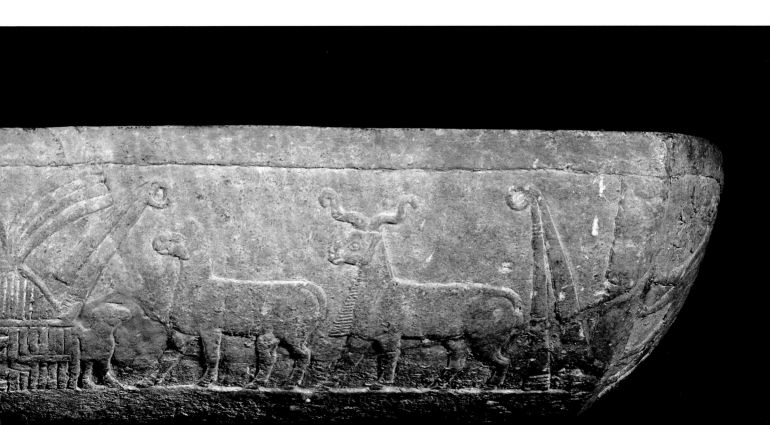

'I am therefore delighted that your Excellency is pleased to possess this further specimen of my art, and think myself fortunate in that another work of mine should be deemed worthy of a place in your select and admirable Gallery. I assure you that I shall apply myself with the utmost ardour and devotion to respond to the singular favour with which you are pleased to honour me.'

Antonio Canova, letter to the Marquis of Lansdowne, 22 February 1821

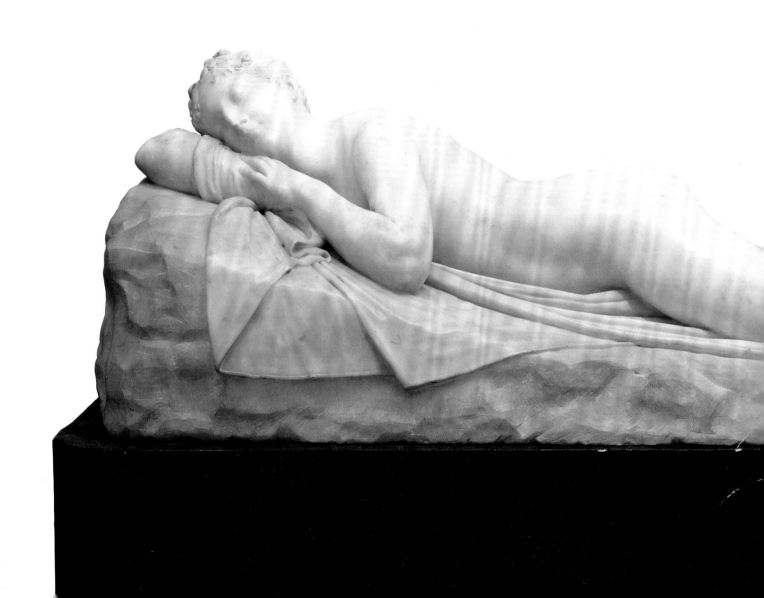

Victoria and Albert Museum, London
Acquired in 1930

THE SLEEPING NYMPH, *c.* 1821–3
Marble, 194.3 long
Antonio Canova (1757–1822)

The Sleeping Nymph was Canova's last work. He completed the model and part of the carving of the figure, but it was finished after his death, under the supervision of his brother. The Marquis of Lansdowne had commissioned the work, which remained in the family collection until the sale of the Lansdowne Marbles in March 1930, when it was purchased by the Fund and presented to the Victoria and Albert Museum. Four contemporary letters purchased with the sculpture give fascinating details of the commission, including the payment of the agreed price of £500 through Messrs Coutts & Co.

'Wilson said, he used to try to paint the effect of the motes dancing in the setting sun... a friend coming into his painting-room when he was sitting on the ground in a melancholy posture, observed that his picture looked like a landscape after a shower: he started up with the greatest delight, and said, "That is the effect I intended to produce, but thought I had failed." Wilson was neglected; and by degrees neglected his art to apply himself to brandy.'

William Hazlitt, 'On the Pleasure of Painting', *Table Talk*, 1821

National Museum of Wales, Cardiff
Acquired in 1930

PEMBROKE TOWN AND CASTLE, *c.* 1765–6
Oil on canvas, 101.6 × 127
Richard Wilson (1713–82)

Richard Wilson was born at Penegoes in Montgomeryshire, and although he trained and spent much of his life in London, the countryside and the castles of Wales were always his real inspiration. In 1750 he went to Italy, remaining for seven years mostly in and around Rome. On his return, he painted exclusively landscapes of strongly Italianate character. His views of Wales were popular with the wealthy local gentry, and *Pembroke Town and Castle* was among several works by him bought by William Vaughan of Corsygedol. It remained with the Vaughan family until its purchase in 1930 by the National Museum of Wales, assisted by the National Art Collections Fund and several private benefactors.

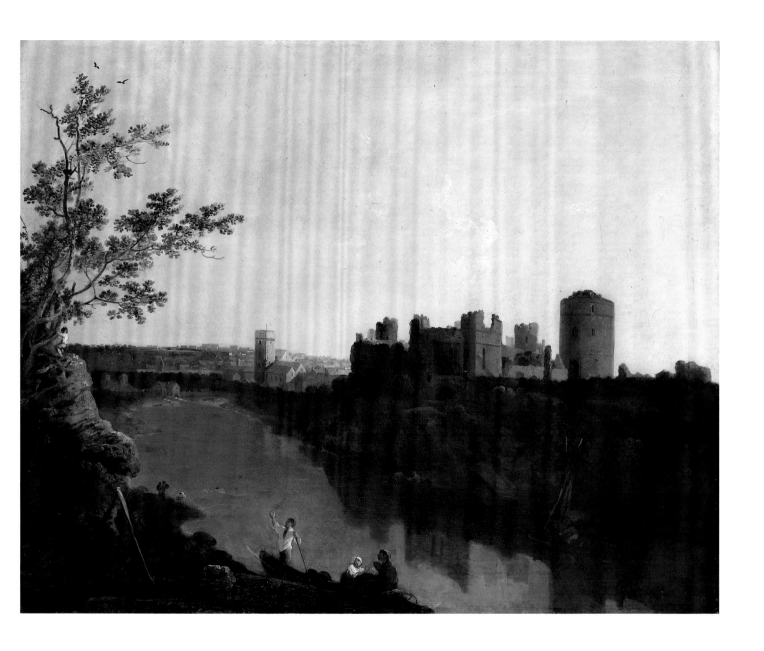

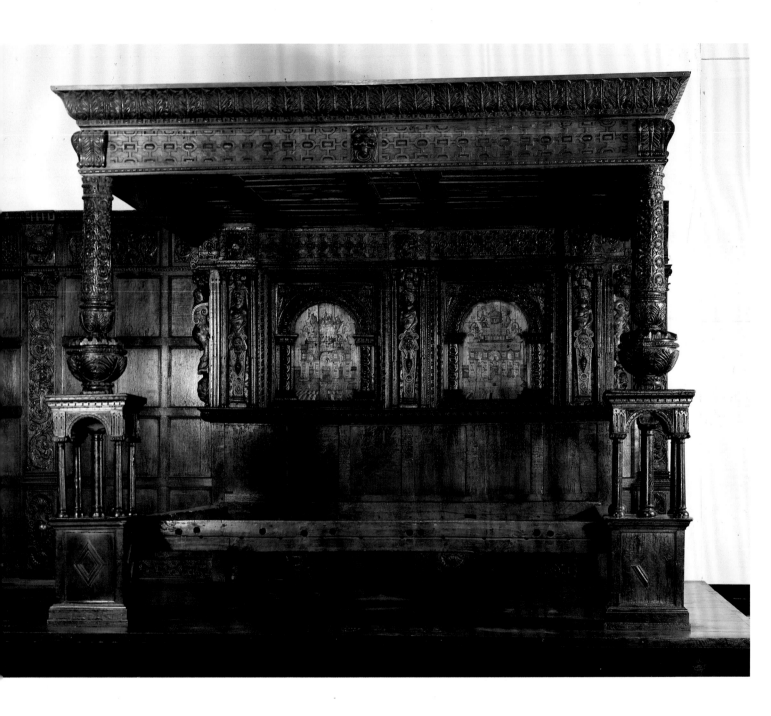

'At Ware was a bed of dimensions so wide
Four couples might cosily lie side by side
And thus without touching each other abide.'

Prince Ludwig of Anhalt-Köhten, *Poetical Itinerary*, 1596

'Most wise men with one *moderate woman wed*
Will scarcely find philosophy for more,
And all (except Mahometans) forbear
To make the nuptial couch a "Bed of Ware".'

Lord Byron, *Don Juan*, VI. xii, 1819–24

Victoria and Albert Museum, London
Acquired in 1931

THE GREAT BED OF WARE, *c.* 1580–90
Oak with inlaid panels in headboard, 266 × 322 × 330

This outsize bed was already well known by 1601, when Shakespeare mentioned it in
Twelfth Night. Despite speculation that it may have been made for Sir Henry Fanshawe of
Ware Park, it seems more likely that it was originally made for use at an inn. In 1612 the
bed was recorded at the White Hart Inn at Ware, and was later at other inns in the town
until its removal to Hoddesdon in the mid-nineteenth century. It has always attracted
attention, and has been alluded to frequently in jest by dramatists, poets and travellers.
In 1931 *The Great Bed of Ware* was acquired by the Victoria and Albert Museum, with
the help of the National Art Collections Fund, through Frank Partridge & Sons, who
displayed it in their London showrooms to help the appeal for funds.

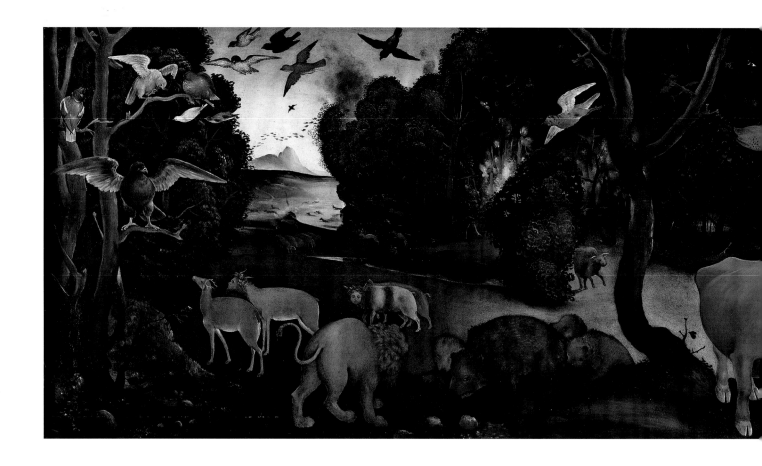

'A small spark, from flint struck, nourished in leaves and small dried
branches, flames up; and, lashed by the swift wind, burns the twig,
shoots and sticks, then near to the thick and dense forest it ignites stone
oak and the old and tall oaks: cruel enemy of the wood fulfills its ire:
smoke, sparks and strange cries fill the air.

Shaded homes, sweet nests, and tall and ancient woodland folds
go up in flames; nor will any beast trust the wood but terrified by the
flames takes flight; various roars and cries fill the sky: the sound terrifies
the opaque valley. The imprudent shepherd, who has fled the fire, weeps,
stupified and disheartened.'

Lorenzo de' Medici, *Selve d'Amore*, I. vii–viii, *c.* 1480

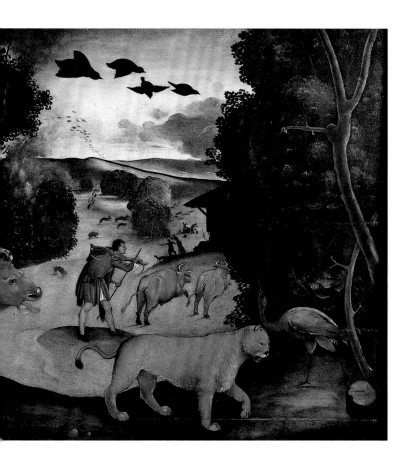

Ashmolean Museum, Oxford
Acquired in 1933

THE FOREST FIRE, late 15th century
Oil on panel, 71.2 × 202
Piero di Cosimo (1461/2–1521)

This panel was one of a series, recorded by Vasari, showing the early history of man,
painted for Francesco del Pugliese in Florence towards the end of the fifteenth century.
Two panels now in the Metropolitan Museum, New York, are believed to belong to the
same series, but an earlier suggestion that *The Battle of the Lapiths and Centaurs* (National
Gallery, London) could also be part of the series is now discounted. Piero di Cosimo's
fascination with animals is evident in this work, which may have been inspired by a
contemporary poem by Lorenzo de' Medici. The painting appeared in an inventory of the
Rucellai family in 1894, and was sold to Prince Paul of Yugoslavia *c.* 1917. It was
purchased from him in 1933 by the National Art Collections Fund and presented to the
Ashmolean Museum.

'He is various and experimental; if I am not mistaken he sees each work that he produces in a light of its own, not turning off successive portraits according to some well-tried receipt which has proved useful in the case of their predecessors; nevertheless there is one idea that pervades them all, in a different degree, and gives them a family resemblance – the idea that it would be inspiring to know just how Velasquez would have treated the theme.'

Henry James, 'John S. Sargent', *Harper's Weekly*, October 1887

Southampton City Art Gallery
Acquired in 1935

CECIL HARRISON (1878–1915), *c.* 1888
Oil on canvas, 172.8 × 83.6
John Singer Sargent (1856–1925)

Cecil Harrison was the eldest son of Robert Harrison, a wealthy stockbroker, and his wife Helen, whose portrait by Sargent was highly praised when exhibited at the Royal Academy in 1886. Major Harrison, as he became, was killed on active service during the First World War. This portrait, painted at a time when Sargent was fascinated by Impressionism, was presented to Southampton City Art Gallery, through the National Art Collections Fund, by the sitter's mother in 1935.

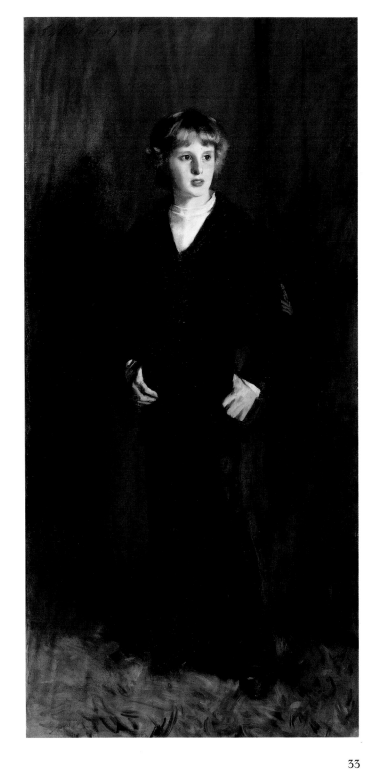

*'Have upon the Stocks the young Nobleman, whose avarice caused
him to break open the Tomb of his ancestors, in hopes of finding vast
treasures, from an inscription there was upon it: "In this tomb is
a greater treasure than Croesus possessed." This, I think, will be
a favourite picture.'*

Joseph Wright of Derby, undated letter to his sister Nancy, *c.* 1772

Derby Museum and Art Gallery
Acquired in 1937

MIRAVAN BREAKING OPEN THE TOMB OF HIS ANCESTORS, 1772
Oil on canvas, 127 × 101.6
Joseph Wright Derby (1734–97)

Although Joseph Wright of Derby tells the story of this painting in his Account Book,
the source has never been satisfactorily explained. The inscription quoted above appears in
the painting in correct and legible Persian script, just above Miravan's turban. Another
similarly accurate inscription is painted on the stone removed from the front of the tomb.
It is odd that there appears to be no contemporary mention of this mysterious work, even
though it was exhibited in 1772, nor is there any record of who owned it. In 1937 the
painting was given by Mr and Mrs A. L. Nicholson, through the National Art Collections
Fund, to Derby Art Gallery. It is now in the recently re-hung room celebrating the work
of this local artist, who is so closely associated with the city as to be always known as Joseph
Wright 'of Derby'.

34

'And so what Rembrandt has alone or almost alone among painters, that tenderness in the gaze… that heartbroken tenderness, that glimpse of a superhuman infinite that there seems so natural, in many places you come upon it in Shakespeare. And then portraits grave or gay, like… the Saskia *– he is full of them, above all.'*

Vincent van Gogh, letter to his brother Theo, June 1888

The National Gallery, London
Acquired in 1938

SASKIA VAN UYLENBURGH IN ARCADIAN COSTUME, 1635
Oil on canvas, 123.7 × 97.5
Rembrandt van Rijn (1606–69)

Rembrandt's wife Saskia van Uylenburgh (1612–42) was the model for this study of a woman in Arcadian dress. It was painted in 1635, the year after their marriage, and belongs to a contemporary fashion, which was literary as well as pictorial, for representing women as shepherdesses, or as Flora, the Roman goddess of spring. Sadly, Saskia, weakened by many pregnancies, was to die in 1642; of their four children, only Titus, born in September 1641, survived into adulthood. The painting was once owned by the Duc de Tallard, and by 1780 was in the Duke of Montagu's collection. It passed, by the marriage of a daughter, to the Dukes of Buccleuch, and was purchased from the family by The National Gallery in 1938, with the help of the National Art Collections Fund.

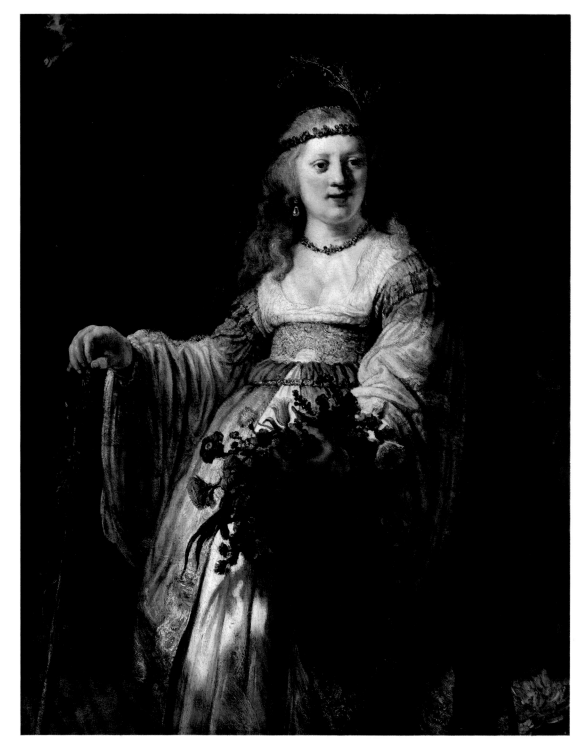

'Mr Townley's marbles and statuary – the Wilton House of London –
are a most remarkably fine subject of a picture in the manner of
Zoffani's gallery of Florence – with some portraits grouped in front –
the specimens of ancient art in the background.'

The Public Advertiser, 7 June 1785

Towneley Hall Art Gallery and Museum, Burnley
Acquired in 1939

CHARLES TOWNELEY AND FRIENDS IN THE PARK STREET GALLERY, WESTMINSTER, 1781–3
Oil on canvas, 127 × 99
Johan Zoffany (1733–1810)

Charles Towneley was born in Burnley in 1737, but educated in France. He began his collection of classical sculpture during a stay in Italy from 1765 to 1772, where he also met Zoffany, who became a close friend. Towneley is seen on the right of the painting, with his dog, Kam, at his feet. The French antiquary, Baron d'Harcarville, who catalogued the collection, sits beside Towneley's prized bust of *Clytie*. On Towneley's death, his collection was purchased by the British Museum (of which he was a trustee), and is now displayed in its own gallery. Towneley Hall, the home of the family since the fourteenth century, was purchased by Burnley Corporation in 1902 to be an art gallery and museum. The painting remained in the family until it was bought by the gallery in 1939, with the assistance of the Fund.

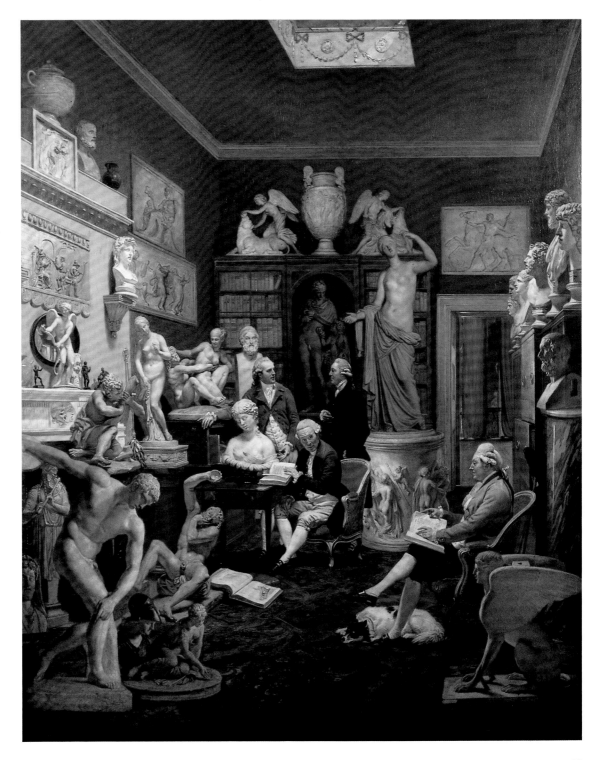

39

'Most of De Wint's early and valuable studies were made at Lincoln and the neighbourhood, where he ever found new beauties and new subjects, and what a commonplace observer would consider flat and unmeaning was in his eye picturesque. The long extensive distances, with their every-varying effects, the flats bordering the river, covered with cattle, the groups of vessels in the Brayford, the cornfields and hayfields and, above all, the magnificent cathedral seen from so many points, afforded him unceasing delight.'

Harriet de Wint (wife of Peter de Wint), manuscript memoirs, n.d.

Usher Gallery, Lincoln
Acquired in 1941

LINCOLN FROM THE SOUTH, 1824
Oil on canvas, 61 × 92.1
Peter de Wint (1784–1849)

Peter de Wint, born in Staffordshire and trained in London, was introduced to Lincolnshire by his student-friend, William Hilton, whose sister Harriet he later married. De Wint became deeply attached to Lincoln and the surrounding countryside, and spent much of his time there, whilst retaining a house in London. He is better known for his watercolours than for oil painting, but the Usher Gallery in Lincoln has built up a fine collection of both to celebrate this local artist. This painting is one of several which were owned by the artist's granddaughter, and after her death by her friend, Miss Bostock, from whose estate the gallery bought it, with the help of the National Art Collections Fund, in 1941.

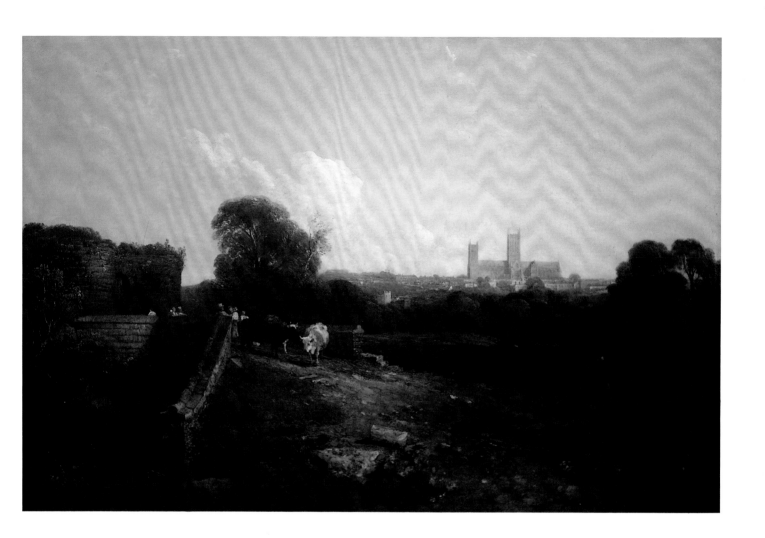

41

'Do not miss seeing my portrait... I like it very much. I am turning away from the 20th century to think only of the 15th.'

'...I am glad you like my portrait. I think hereafter it will seem "likely", that is the most one can expect of a portrait – I look as if I had written to Ariosto, the book at my side has been sent to me by Aretino with a hint that a silk doublet would be acceptable. We are in A.D. 1515.'

Charles Ricketts, letters to Katherine Bradley and Edith Cooper, 1898

National Portrait Gallery, London
Acquired in 1942

CHARLES RICKETTS (1866–1931), 1898
Oil on canvas, 95.3 × 99.1
Charles Shannon (1863–1937)

Ricketts and Shannon met as students and formed a lifelong friendship, living and working together on a variety of projects. These included wood-engraving and printing, as well as painting and designing for the stage. They were both critics and passionate collectors of works of art, who sold or gave, in their lifetimes, and at their deaths bequeathed many works to British public collections. Furthermore, both were founder members of the National Art Collections Fund, in which they took the keenest interest, and Ricketts served for several years on the Executive Committee. This portrait, and a self-portrait by Shannon, were purchased by the Fund in 1942 and presented to the National Portrait Gallery.

M · D · CCC · XC · VIII

43

'As for me, I have no chance of getting away just now, as I am tied down to my canvas till all the flower part of it is finished. I have done many more roses, and have established an arrangement with a nursery-gardener at Cheshunt, whereby they reach me every two days at 2s. 6d. for a couple of dozen each time, which is better than paying a shilling apiece at Cov[ent] Garden. Also honeysuckles I have succeeded in getting at the Crystal Palace, and have painted a lot already in my foreground, and hope for more.'

Dante Gabriel Rossetti, letter to his mother, 16 August 1864

Russell-Cotes Art Gallery and Museum, Bournemouth
Acquired in 1945

VENUS VERTICORDIA, 1864–8
Oil on canvas, 98 × 69.9
Dante Gabriel Rossetti (1828–82)

In 1908 Sir Merton and Lady Russell-Cotes presented the extravagant late Victorian villa, East Cliff Hall, to the town of Bournemouth. The villa had been built next to the Royal Bath Hotel, which they also owned, to house their rapidly expanding art collection, which had already outgrown the public rooms at the hotel. The taste of the donors has continued to dominate the collection, and the purchase in 1945, with the help of the National Art Collections Fund, of Rossetti's sensuous painting, rich in sexual symbolism, was an appropriate addition. The work hangs in the Main Hall of the museum, parts of which have recently been refurbished.

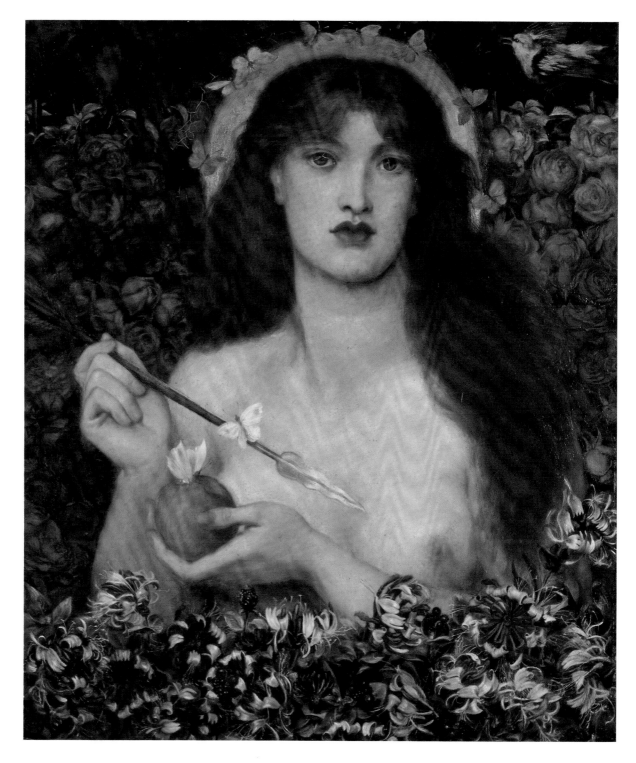

'And when Joshua heard the noise of the people as they shouted,
he said unto Moses, There is a noise of war in the camp.

And he said, It is not the voice of them that shout for mastery,
neither is it the voice of them that cry for being overcome: but the
noise of them that sing do I hear.

And it came to pass, as soon as he came nigh unto the camp,
that he saw the calf, and the dancing: and Moses' anger waxed
hot, and he cast the tables out of his hands, and brake them
beneath the mount.'

The Bible, Exodus 32: 17–19

The National Gallery, London
Acquired in 1945

THE ADORATION OF THE GOLDEN CALF, late 1630s
Oil on canvas, 154.3 × 214
Nicolas Poussin (1594–1665)

This work, together with its pendant *The Crossing of the Red Sea* (now in the National
Gallery of Victoria, Melbourne), was painted in the late 1630s for Amadeo dal Pozzo,
Marchese di Voghera, of Turin, a cousin of Poussin's great patron in Rome, Cassiano dal
Pozzo (see page 160). Both paintings were in Paris by about 1685, and in French collections
until they were brought to England in 1741 by Sir Jacob Bouverie, whose successor became
Earl of Radnor. The paintings remained together at the family seat, Longford Castle, until
this work was purchased by The National Gallery in 1945, with the help of the National
Art Collections Fund.

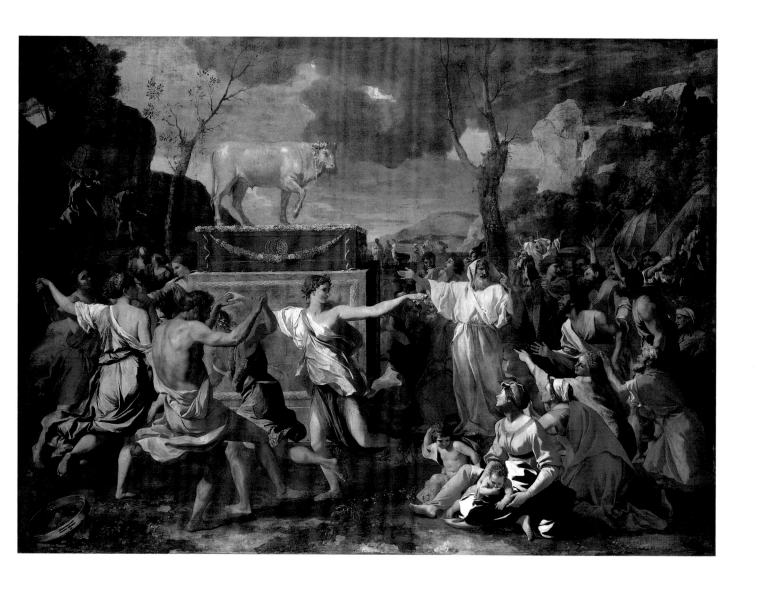

'I love Brittany; I find there the savage, the primitive. When my clogs resound on the granite soil, I hear the muffled, dull, powerful tone that I seek in my painting.'

Paul Gauguin, letter to his friend and fellow artist, Emile Schuffenecker, March 1888

Laing Art Gallery, Newcastle upon Tyne
Acquired in 1945

THE BRETON SHEPHERDESS, 1886
Oil on canvas, 60.4 × 73.3
Paul Gauguin (1848–1903)

Works dating from Gauguin's first stay in Brittany are still impressionistic in style and technique, but it was 'the savage and thrilling majesty of nature' that appealed to him in Brittany, and was eventually to lead him to abandon France to seek more exotic surroundings in Tahiti. This is probably the painting Gauguin mentions selling to a fellow artist, Fauche, for 150 francs in 1888. It was later in the collection of Mrs Fulford, an artist and art lover who bequeathed her house and its contents, as well as her art collection, to the National Art Collections Fund in 1945. The paintings were presented by the Fund to several art galleries.

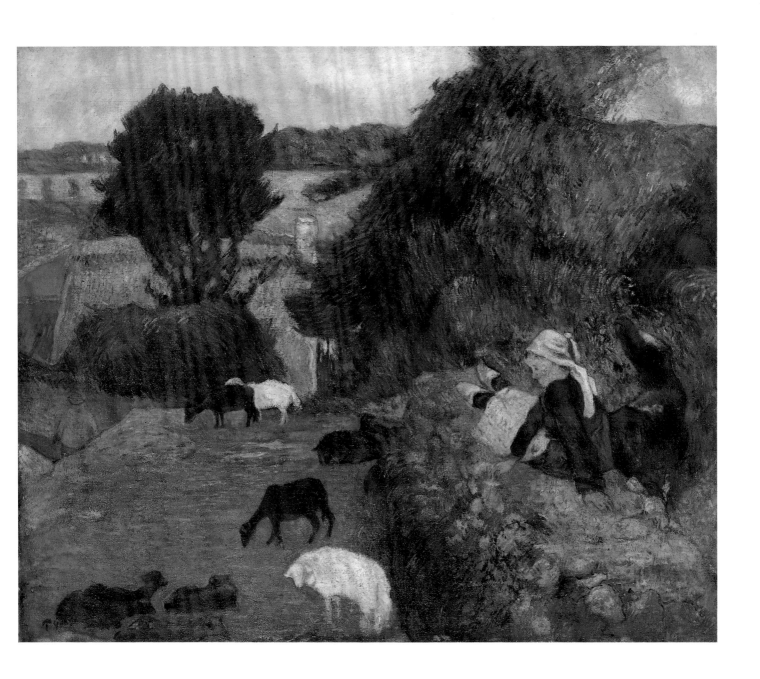

'Mr Kettle is so improved an artist since his return from India that there is no doubt that he will soon be able to make the pot boil handsomely.'

The Painters' Mirror, 1781

Hove Museum and Art Gallery
Acquired in 1948

FRANCES GRAHAM, 1777
Oil on canvas, 130 × 103
Tilly Kettle (1735–86)

Tilly Kettle's success as a painter of portraits in London was modest, and the competition fierce. Probably insulted at not being chosen as one of the original forty members of the newly formed Royal Academy, he set out for India in 1768. In Madras and later in Bengal he secured commissions to paint portraits of British residents, and became successful and affluent. In 1776 he returned to England with a small fortune and some reputation, but wider success continued to elude him. His former patrons, now returned to England, provided most of his work. In Calcutta in 1774 he had painted portraits of both Mr and Mrs John Graham, and this portrait of their daughter, with a parrot and wearing a dress of Indian muslin, painted in England, must have served as a reminder of India. Donated by the National Art Collections Fund to Hove Museum and Art Gallery in 1948, it is one of the delights of the recently redecorated picture gallery.

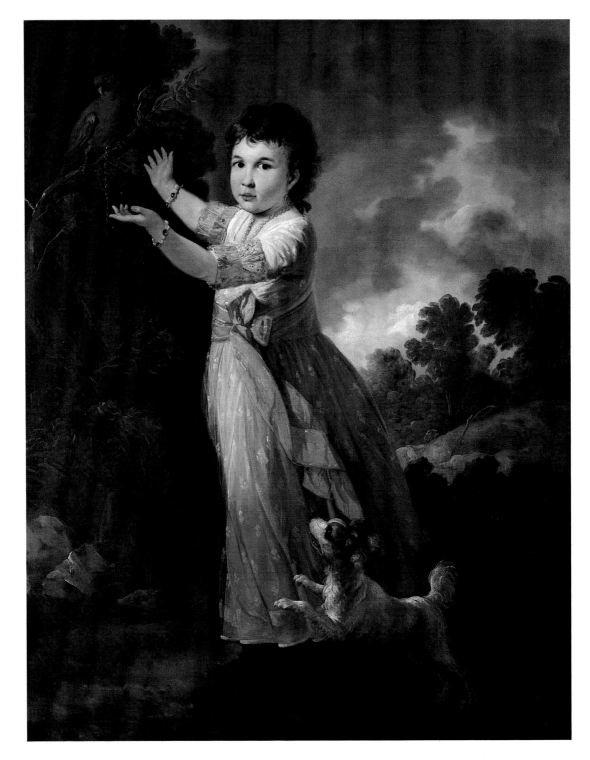

'Voltaire, the prince of poets, the patriarch of philosophers, the glory of his age and country…

Destitute, nevertheless, of rank, birth, or authority, his power consisted only in the clearness of his reasoning, in the varied eloquence of his style, and in the captivating grace of his manner… he for the most part employed, not the heavy club, but the light arms of ridicule and irony. It is certain that none ever made a more dexterous use of them than he did, or inflicted with them deeper and more incurable wounds…

His leanness bore witness to his long incessant labour… His piercing eye sparkled with genius and sarcasm; in it might be traced the fire of the tragic poet, the author of Oedipus and of Mahomet, of the profound thinker, the ingenious and satiric novelist, the severe and penetrating observer of human nature, while his thin and stooping form seemed nothing more than a flimsy, almost transparent cover, through which shone forth his genius and his soul.'

Louis Philippe, Comte de Ségur, *Memoirs*, 1778

Victoria and Albert Museum, London
Acquired in 1948

VOLTAIRE (1694–1778), 1781
Marble, 49.5 high (including base)
Jean-Antoine Houdon (1741–1828)

From 1755 Voltaire lived in exile at Ferney, near Lake Geneva, and it was on a rare visit to Paris in 1778 that he sat for Houdon, and also met the Comte de Ségur, whose mother was an old friend. Voltaire died in Paris at the end of May 1778, and Houdon's celebrated seated figure of him (now at the Comédie-Française), as well as several busts, of which this is one, were completed posthumously. The head is a reproduction of that of the larger statue. The purchase of the bust by the Victoria and Albert Museum in 1948, with the assistance of the Fund, was particularly significant since it was the first example of Houdon's work to enter the collection.

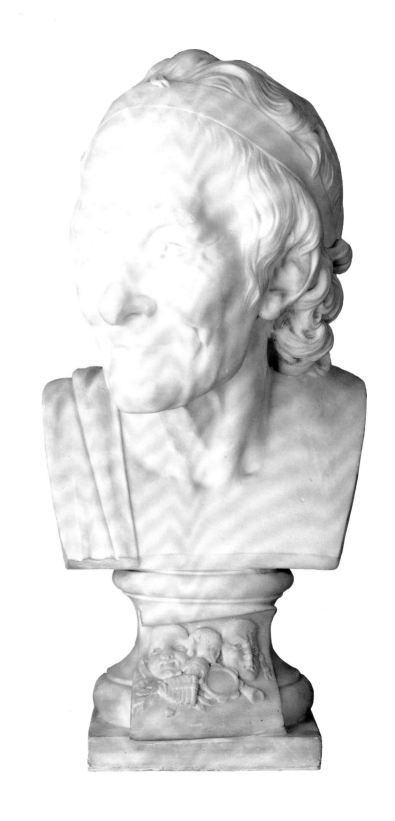

'*A taking picture, much, it seems to me, above Mr. Frith's former standard. Note the advancing Pre-Raphaelitism in the wreath of leaves round the child's head. One is only sorry to see any fair child having too many and too kind friends, and in so great danger of being toasted, toyed and wreathed into selfishness and misery.*'

John Ruskin, *Academy Notes*, 1856

To which Mr Frith, no lover of the Pre-Raphaelites, retorted:

'*Ruskin's works bristle with errors; one of his notable ones was his saying, on the discovery of a bit of what he took for pre-Raphaelitic work in one of the worst pictures I ever painted, that I was "at last in the right way", or words to that effect.*'

William Powell Frith, *Autobiography and Reminiscences*, 1887

Mercer Gallery, Harrogate
Acquired in 1951

MANY HAPPY RETURNS OF THE DAY, 1856
Oil on canvas, 80 × 112
William Powell Frith (1819–1909)

The setting of this painting is the dining room of Frith's house in Pembridge Villas, Bayswater, and portraits of several members of the artist's family are included. The birthday celebrated is that of his daughter, Alice, he himself is the father on the right, and his mother is shown as the grandmother. The picture was purchased with the help of the National Art Collections Fund in 1951 by the Art Gallery in Harrogate – the town where Frith spent some of the early years of his life, and where his father was landlord of the Dragon Inn. It now hangs in the Mercer Gallery, Harrogate. In 1991 the sketch for the painting also returned to Yorkshire, when it was purchased by York City Art Gallery with the help of the Fund.

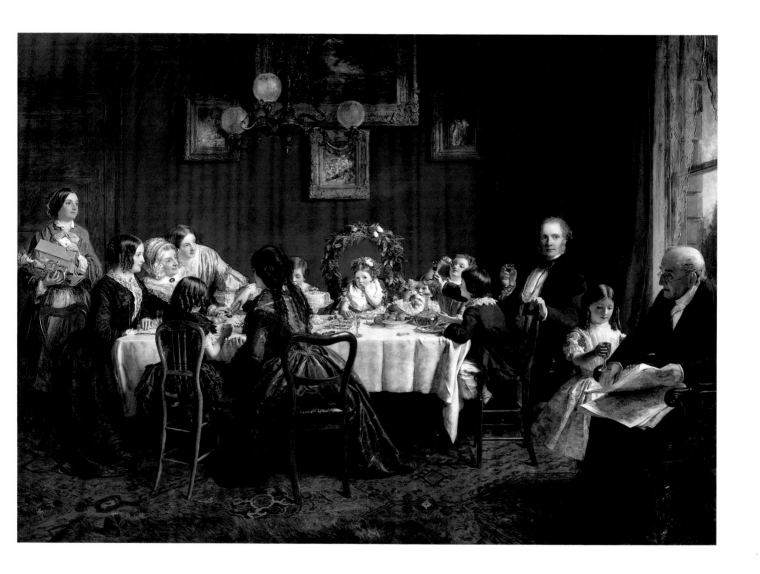

'On a rock, whose haughty brow
Frowns o'er old Conway's foaming flood,
Robed in the sable garb of woe,
With haggard eyes the Poet stood;
(Loose his beard, and hoary hair
Stream'd, like a meteor, to the troubled air)
And with a Master's hand, and Prophet's fire,
Struck the deep sorrows of his lyre.'

Thomas Gray, *The Bard*, 15–22, 1757

Laing Art Gallery, Newcastle upon Tyne
Acquired in 1951

THE BARD, 1817 (exhibited)
Oil on canvas, 213.4 × 154.9
John Martin (1789–1854)

Martin's painting illustrates Thomas Gray's Pindaric ode, *The Bard*, which was based on a tradition, then current in Wales, that when Edward I conquered the country, he ordered all bards to be put to death. The poem provided a suitably, and typically, melodramatic subject for Martin, whose large history paintings were popular in the early nineteenth century. Martin was born at Haydon Bridge near Newcastle, and appropriately the Laing Art Gallery in Newcastle has built up a fine collection of his paintings and those of his contemporaries. The gallery was able to purchase this work in 1951, with the help of the National Art Collections Fund.

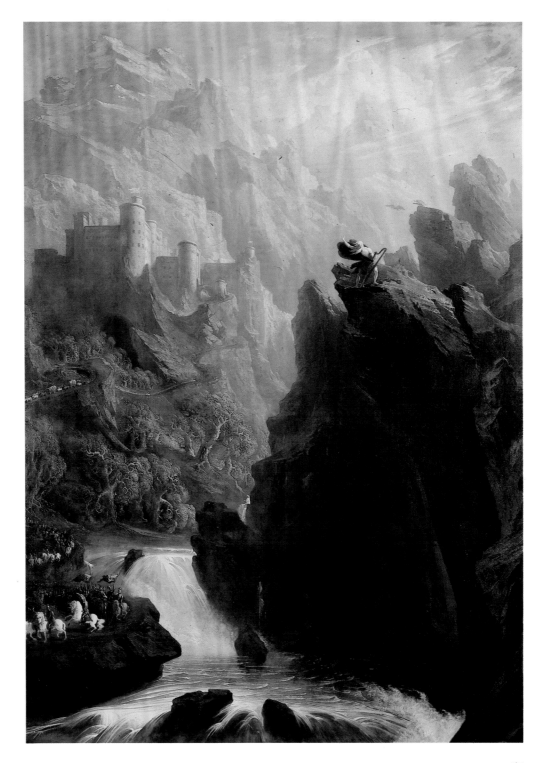

'The terrible realism of this statuette makes the public distinctly uneasy, all its ideas about sculpture, about cold, lifeless whiteness, about those memorable formulas copied again and again for centuries, are demolished. The fact is that on the first blow, M. Degas has knocked over the traditions of sculpture, just as he has for a long time been shaking up the conventions of painting... this statuette is the only truly modern attempt I know in sculpture.'

Joris-Karl Huysmans, 'L'exposition des indépendants en 1881', *L'Art Moderne*, 1883

Tate Gallery, London
Acquired in 1952

LITTLE DANCER AGED FOURTEEN, 1880–81, cast *c.* 1922
Bronze, with muslin *tutu* and satin hair ribbon, 98.4 high
Edgar Degas (1834–1917)

The original wax statuette, known as *Little Dancer of Fourteen Years* (now in the collection of Mr and Mrs Paul Mellon, Upperville, Virginia), was listed in the catalogue of the 1880 exhibition of Impressionists, but was not completed in time, and the glass case specially built for it remained empty. It was, however, ready for the following year's exhibition, when its 'frightful realism' provoked strong, mostly adverse, reaction from the critics. This bronze was cast after Degas' death by A. A. Hébrard, the founder who cast all his bronzes, and Degas' niece, Mlle Lefèvre, dressed the dancer, like the original, in a muslin *tutu* and satin hair ribbon. The statuette, unique in Degas' *oeuvre*, was purchased by the Tate Gallery with the help of the National Art Collections Fund in 1952, from Hébrard's son-in-law.

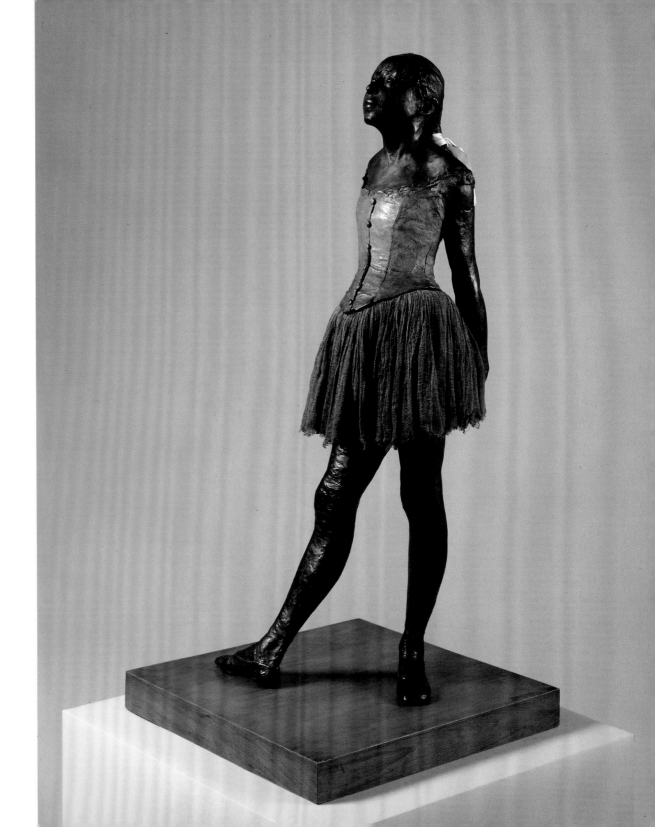

'How do I envy you the Pleasures of the Country? while I poor dog lize sweating at the Easel you are ramping over hedge & Ditch knocking down Partriges or Country girls the better of the two, all our solace in town this hot Weather is getting drunk ...'

Francis Hayman, letter to Sir Edward Littleton, 4 August 1750

'...a strong mannerist, and easily distinguishable by the large noses and shambling legs of his figures. In his pictures his colouring was raw, nor in any light did he attain excellence. He was a rough man, with good natural parts, and a humourist – a character often tasted by contemporaries, but which seldom assimilates with or forgives the rising generation.'

Horace Walpole, *Anecdotes of Painting in England*, 1762

Royal Albert Memorial Museum, Exeter
Acquired in 1953

PORTRAIT OF THE ARTIST AT HIS EASEL, 1750
Oil on canvas, 60.7 × 43.5
Francis Hayman (1708–76)

This self-portrait, probably painted as a companion to Hayman's portrait of Sir Edward Littleton, may have been presented to Littleton by the artist. Hayman was a versatile painter, whose most celebrated work was the decoration of the supper boxes at Vauxhall Gardens – some canvases survive in the Victoria and Albert Museum. The artist's casual dress in this portrait is reminiscent of the informality of the statue of Handel by his friend Roubiliac, which was also in Vauxhall Gardens (see page 90). Francis Hayman was born near Exeter, though he spent most of his life in London. This portrait remained with Sir Edward Littleton's descendants until 1953, when it was purchased by the National Art Collections Fund and presented to the Royal Albert Memorial Museum, Exeter.

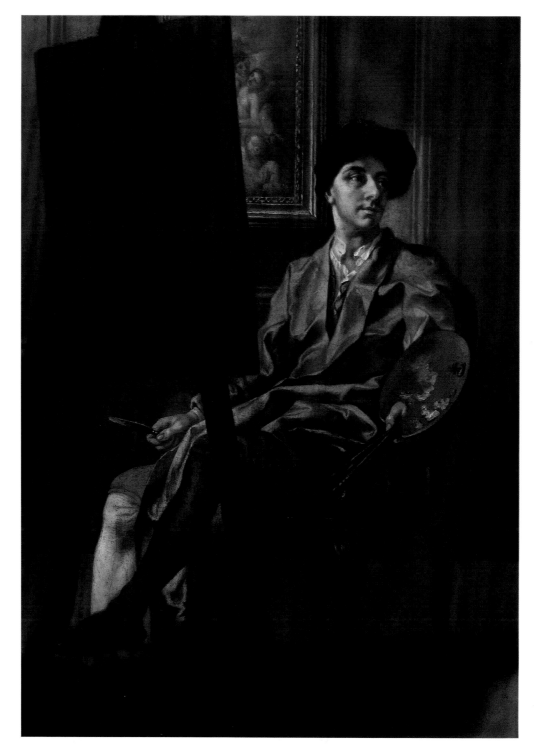

'Art cannot exist without life. If a sculptor wishes to interpret joy, sorrow, any passion whatsoever, he will not be able to move us unless he first knows how to make the beings live which he evokes. For how could the joy or the sorrow of an inert object – of a block of stone – affect us? Now, the illusion of life is obtained in our art by good modelling and by movement. These two qualities are like the blood and the breath of all good work.'

Auguste Rodin, *On Art and Artists*, 1911

Tate Gallery, London
Acquired in 1953

THE KISS, 1901–4
Marble, 182.2 high
Auguste Rodin (1840–1917)

This is the third version of *The Kiss* – possibly Rodin's most celebrated work. The first was executed in 1886, exhibited at the Salon in 1898, and is now in the Musée Rodin in Paris. The second is in Copenhagen. This version, commissioned from Rodin by the Anglo-American antiquarian, Edward Warren, in 1900, was completed in 1904. Assistants working under Rodin's supervision were responsible for the carving, for despite his consummate skill in modelling in clay, Rodin scarcely ever worked in stone. Warren's secretary, who inherited the work, loaned it first to Cheltenham Art Gallery and then for twelve years to the Tate Gallery, before deciding to sell it. The Tate Gallery purchased *The Kiss* in 1953, with the assistance of the National Art Collections Fund and public contributions.

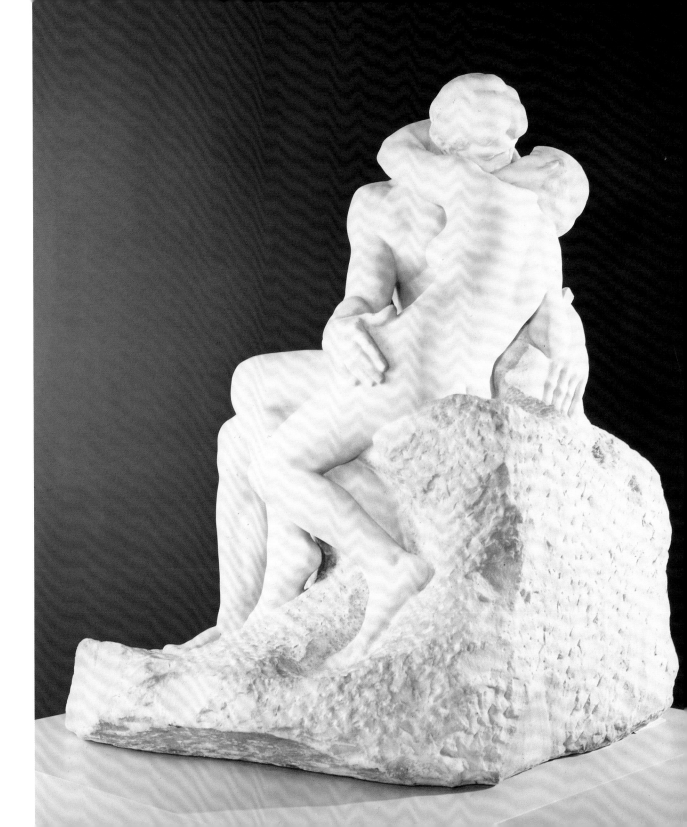

'My Lord of Buckingham *return'd to Court yesternight, much discolour'd and lean with Sickness, the Dearness betwixt the Prince and him still continuing, and outwardly all appearing very serene towards him, yea not so much as* York-House *but goes on passing fast, another Corner symmetrical now appearing answerable to that other raised before you went hence, besides a goodly Statue of Stone set up in the Garden before the new Building, bigger than the Life, of a* Sampson *with a* Philistine *betwixt his Legs, knocking his Brains out with the Jaw-bone of an Ass.'*

Sir Thomas Wentworth, Earl of Strafford, letter to Christopher Wandesford, 17 June 1624

Victoria and Albert Museum, London
Acquired in 1954

SAMSON AND A PHILISTINE, early 1560s
Marble, 209 high
Giovanni Bologna, also called Giambologna (1529–1608)

This marble group originally surmounted a fountain, commissioned by Francesco de' Medici. In 1601 the complete fountain was sent to Spain by the Medici family as a gift for the Duke of Lerma, chief minister of Philip III, but twenty-two years later the sculpture was detached from the basin of the fountain, and given to Charles, Prince of Wales (later Charles I), who brought it to England and presented it to his favourite, George Villiers, Duke of Buckingham. The work was installed in the garden of the Duke's London home, York House, which was then being renovated. It was later moved to Buckingham House, but when George III acquired the house for his palace in 1762, he gave the sculpture to his Surveyor-General, Thomas Worsley of Hovingham Hall in Yorkshire. As the only large-scale work by Giambologna outside Italy, its purchase from Hovingham Hall by the Victoria and Albert Museum in 1954, with the help of the National Art Collections Fund, was of singular importance.

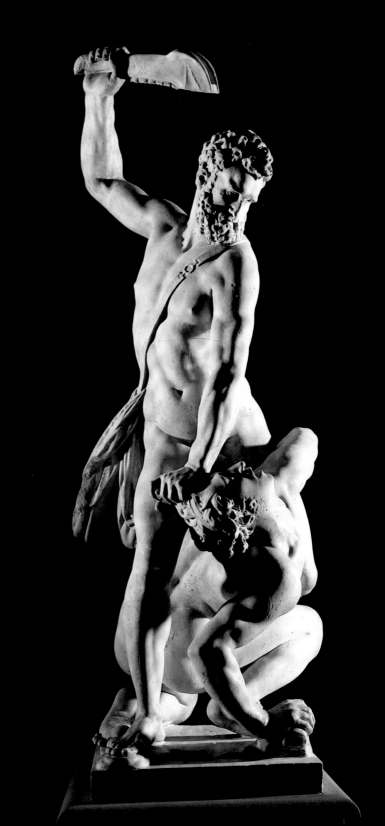

'It was about Noone, I ask't what we might have to dinner: they told me, That they had nothing but egges... she saw I was a young Lad, ruddy-cheek't, full-fac't, and plumpe withall; that I was a novice in the world, and look'd like a good honest simple Youth, and that any thing would serve me well inough... she presently powr'd me foorth upon a plate a Froize of egges, which might more truly have been tearmed a Plaister of egges: they, the bread, the Jarre, the water, the Salt-sellar, the salt, the linnen, and the Hostesse, were all one; so well did they suit together.'

Matheo Alemán, *The Life of Guzmán de Alfarache, c.* 1615

National Gallery of Scotland, Edinburgh
Acquired in 1955

AN OLD WOMAN COOKING EGGS, 1618
Oil on canvas, 100.5 × 119.5
Diego Velázquez (1599–1660)

This is one of several kitchen scenes (*bodegones*) painted when the artist was still in Seville, his birthplace, having completed his training at the academy of Francisco Pacheco, his future father-in-law. The scene closely corresponds to a description in Alemán's contemporary novel, which may have been its inspiration. The early history of the painting is unknown, but it appeared in a sale catalogue in England in 1813. By the 1860s it had entered the collection of Sir Francis Cook, and thereafter was shown at several exhibitions of Old Masters. It remained in the Cook family collection, on extended loan from 1947 to 1955 to the Fitzwilliam Museum, Cambridge, until its purchase from the Trustees of the Cook Collection by the National Gallery of Scotland in 1955, with the help of the National Art Collections Fund.

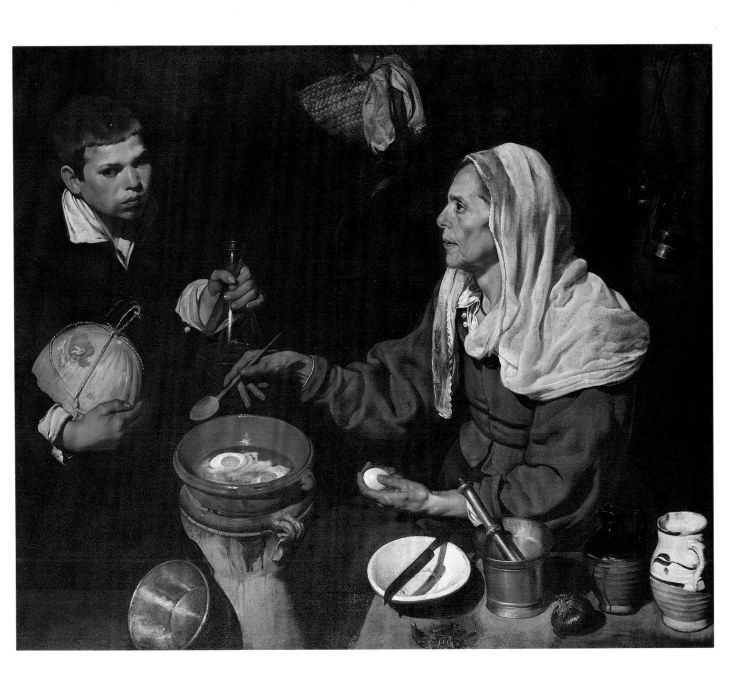

'From the window where I am writing I see all those sweet feilds where we have passed so many happy hours together. It is with a melancholy pleasure that I revisit those scenes that once saw us so happy — yet it is gratifying to me to think that the scenes of my boyish days should have witnessed by far the most affecting event of my life.'

John Constable, letter to Maria Bicknell, 22 June 1812

Christchurch Mansion, Ipswich
Acquired in 1955

GOLDING CONSTABLE'S FLOWER GARDEN, 1815
Oil on canvas, 33 × 50.8
John Constable (1776–1837)

The view from the back of his father's house was especially emotive for John Constable because of its associations with Maria Bicknell, the granddaughter of the Rector of East Bergholt, with whom he fell deeply in love in 1809. Their long courtship, from which many poignant letters survive, lasted until they finally married in 1816, despite the continuing opposition of her grandfather. This painting and its companion, *Golding Constable's Kitchen Garden*, came to Ipswich in 1955 on the death of Ernest Cook, grandson of Thomas Cook of travel agency fame. Ernest Cook bequeathed his large collection to the National Art Collections Fund, and it was distributed to many different galleries and museums throughout the country.

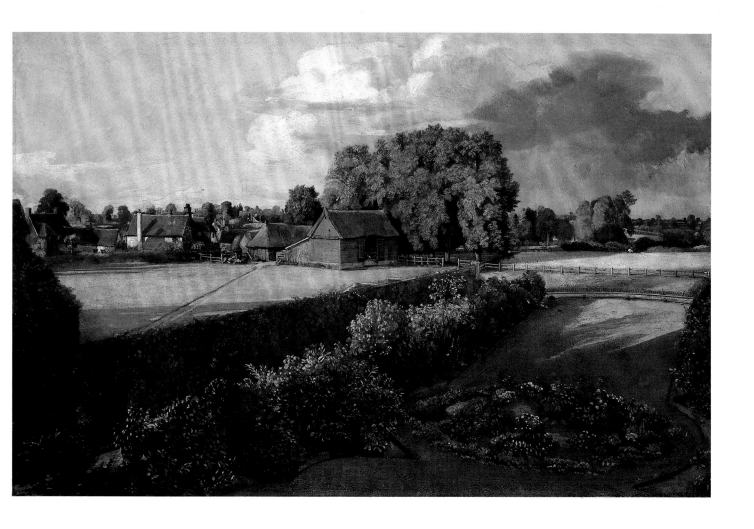

'Straight across, before my windows, rose the great pink mass of San Giorgio Maggiore, which has for an ugly Palladian church a success beyond all reason. It is a success of position, of colour, of the immense detached Campanile, tipped with a tall gold angel. I know not whether it is because San Giorgio is so grandly conspicuous, with a great deal of worn, faded-looking brickwork; but for many persons the whole place has a kind of suffusion of rosiness... It is a faint shimmering, airy, watery pink; the bright sea-light seems to flush with it and the pale whiteish-green of lagoon and canal to drink it in. There is indeed a great deal of very evident brickwork, which is never fresh or loud in colour, but always burnt out, as it were, always exquisitely mild.'

Henry James, 'Venice', *Century Magazine*, November 1882

Temple Newsam House, Leeds
Acquired in 1955

SAN GIORGIO MAGGIORE, VENICE, after 1760
Oil on canvas, 47.6 × 87.6
Francesco Guardi (1712–93)

In that he painted views of Venice, which were immensely popular with tourists, Francesco Guardi followed in the footsteps of Canaletto – indeed a contemporary diarist recorded that Guardi was Canaletto's pupil. However, his handling is less meticulous than Canaletto's, and his freer manner, clear tonality and skill at capturing the effects of the Venetian light have always ensured his popularity, especially with the English. This enchanting atmospheric view of Venice is another work from the extensive Ernest Cook bequest. It was presented to the City of Leeds through the National Art Collections Fund in 1955, for display at Temple Newsam House.

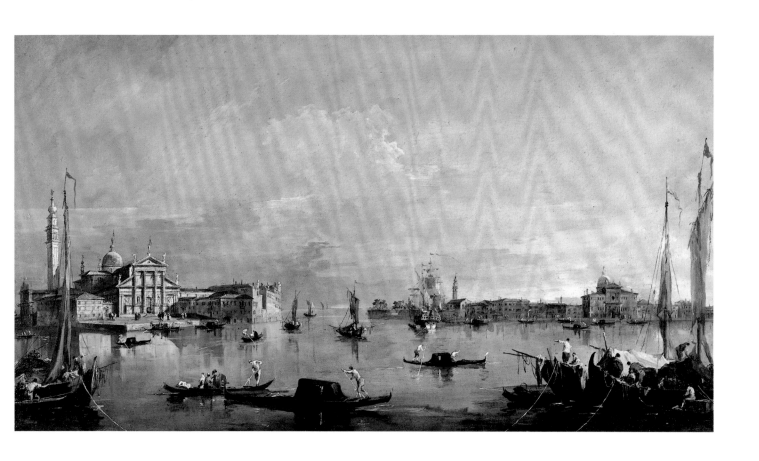

'…Those painted by Don Luis Melendez *especially are superior to any thing of that kind. I gazed over several of them with admiration. The man is still alive: but king Ferdinand and queen Barbara who kept him long employed in that work, forgot to make any provision for him, and I am told that he lives now in poverty and obscurity. Indeed, it is great pity if this is true! So excellent an artist would have made a great fortune in England, and in a little time.'*

Joseph Baretti, Secretary for Foreign Correspondence to the Royal Academy of Painting, Sculpture, and Architecture, letter from Madrid, 8 October 1760

York City Art Gallery
Acquired in 1955

STILL LIFE WITH LEMONS AND NUTS, 1770
Oil on canvas, 37.1 × 50.1
Luis Meléndez (1716–80)

F. D. (known as 'Peter') Lycett Green came from a prosperous Yorkshire engineering family. After the First World War, he started collecting European paintings of the highest quality, although, he admitted, because of his relatively modest budget, not by the most famous artists. Over the years he formed a collection of choice and unusual paintings. On his death in 1955 he bequeathed, through the National Art Collections Fund, over one hundred Old Master paintings to York City Art Gallery, and this generous bequest helped to establish a collection of international importance at York. Meléndez, born in Naples, but active mainly in Madrid, became a distinguished still-life specialist and was patronised by King Ferdinand VI. The majority of his work has remained in Spain.

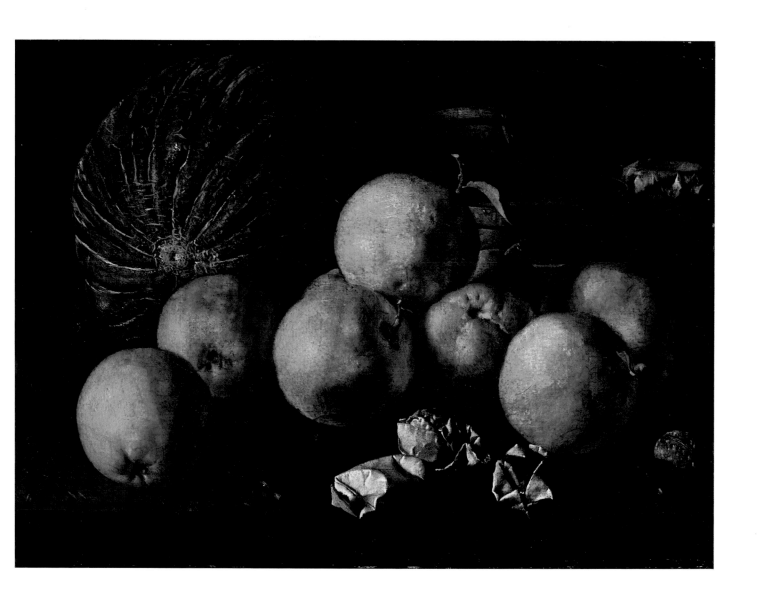

'I never in my life saw such brilliant piercing eyes as Mr Garrick's are. In looking at him, when I have chanced to meet them, I have really not been able to bear their lustre.'

Fanny Burney, Diary, 8 May 1771

'Our Garrick's a sallad, for in him we see
Oil, vinegar, sugar, and saltness agree!'

Oliver Goldsmith, in James Boswell, *Life of Johnson*, 1791

Walker Art Gallery, Liverpool
Acquired in 1956

DAVID GARRICK AS RICHARD III, *c.* 1742–5
Oil on canvas, 190.5 × 250.8
William Hogarth (1697–1764)

David Garrick (1717–79) was born in Hereford and educated at Lichfield as a pupil of Dr Johnson, whom he accompanied to London. Garrick soon turned to the stage, making his London *début* in Shakespeare's *Richard III*. The performance was very well received, and heralded the start of a successful and versatile career as actor, writer and producer. He became a good friend of the painter, William Hogarth, whose paintings he collected and to whom he dedicated a play. This picture, celebrating one of Garrick's most famous performances, was painted for Thomas Duncombe of Duncombe Park, Yorkshire, and remained in his family until it was purchased by the Walker Art Gallery, Liverpool, in 1956, with the help of the National Art Collections Fund.

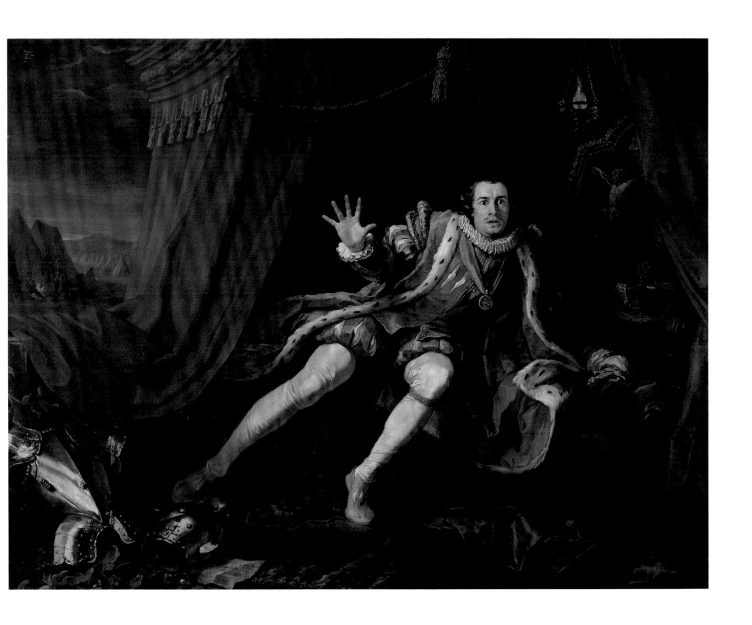

'... another artist was engaged on the Calf Island, off the south coast, upon a small monument which for fineness and delicacy of workmanship exceeds anything that is known of stone work of that early period, while in respect of the treatment, which is early Byzantine art, it is unique...

The richness of ornamentation is on the robe, the "Tunica Palmata", which is covered with a simple but effective design of fine diagonal lines and, below, with alternate rows of small pellets, bordered by heavy cords. It is fastened at the breast by a circular brooch, decorated with a figure-of-eight plait.'

P. M. C. Kermode, *Manx Crosses*, 1907

Manx Museum, Douglas, Isle of Man
Acquired in 1956

'CALF OF MAN' CRUCIFIXION, first half of the 9th century
Manx slate, approx. 66.1 × 24.1

This is one of the earliest representations of the Crucifixion in stone in the British Isles, forming a stylistic link between the Late Antique art of the eastern Mediterranean and the Irish style: 'frank in its barbarism and total rejection of classical figure style'. Christ is shown alive and clothed; the pattern on his robe closely resembles contemporary Irish bronze ornament. The plain lower half of the slab was presumably intended to be set in the ground, and the carving would have been the central panel of an altar. The incomplete slab, made of local Manx slate, was found in 1773 in the ruins of an Early Christian chapel, by workmen building field walls. The work descended through the finder's family until 1956, when it was purchased by the National Art Collections Fund and donated to the Manx Museum.

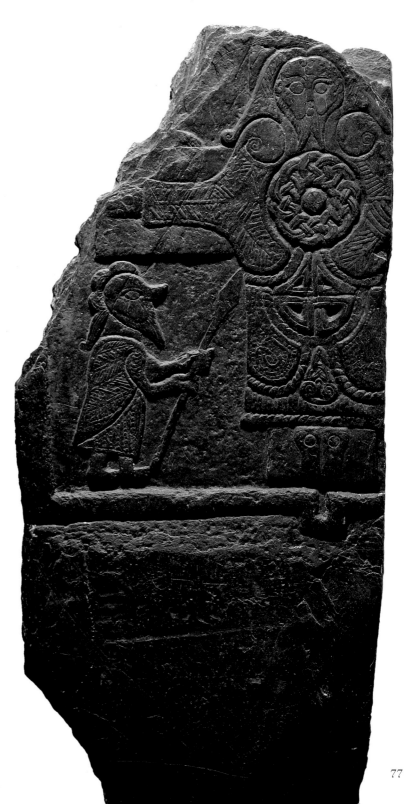

'Often too men hunt the timid wild ass, the hare
And fallow deer with hounds:
Often again their barking will start a wild boar and drive him
From where he wallows in the wood; or in full cry they'll hunt a
Noble stag over the uplands and manoeuvre him towards the nets.'

Virgil, *The Georgics*, III. 409–13, 39–29 BC

Hastings Museum and Art Gallery
Acquired in 1956

MAIOLICA DISH, 1593–4
Italian maiolica, 73.3 diameter

This maiolica dish is unusual due to its remarkable size – nearly 74 centimetres in
diameter – and because it is signed and dated by both potter and painter. The meaning
of the inscription on the back (*'Federichus de Mutanus fecit'*) is, however, not at all clear.
It was once thought to mean that Federichus either came from or worked in Modena,
but recent studies suggest that the shape, reverse and style of decoration, particularly the
figures, indicate an origin in Tuscany or Deruta. The dish was in England by 1862, and
noted in several distinguished collections before it came on to the market in 1956. With
the help of the National Art Collections Fund, Hastings Museum and Art Gallery was able
to secure this work, which the curator particularly coveted for his gallery illustrating the
history of pottery and porcelain. It now forms the striking centrepiece of the display in
the newly refurbished first-floor gallery of this delightful small museum.

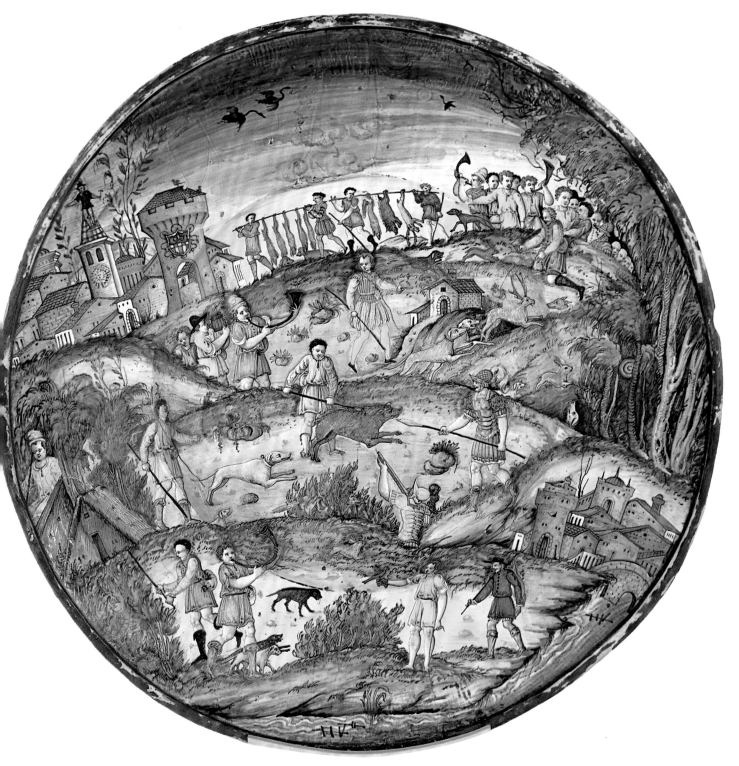

'...And the Lord spake unto the fish, and it vomited out Jonah upon the dry land.'

The Bible, Jonah 2: 10

'And the Lord God prepared a gourd, and made it to come up over Jonah, that it might be a shadow over his head, to deliver him from his grief. So Jonah was exceeding glad of the gourd.'

The Bible, Jonah 4: 6

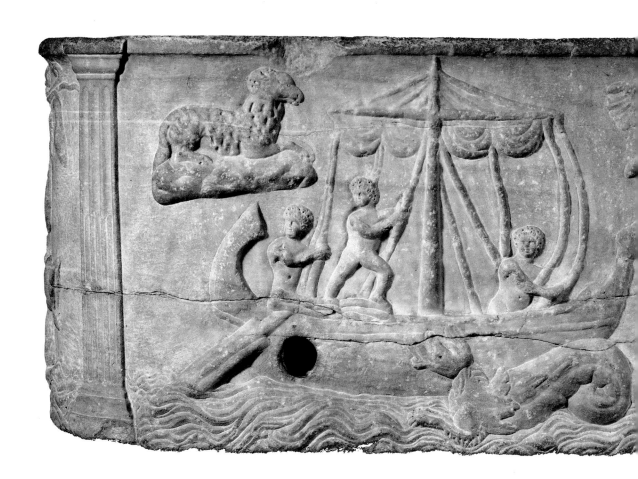

British Museum, London
Acquired in 1957

MARBLE SARCOPHAGUS, *c.* AD 300
Marble, 62 × 187 × 78

This sarcophagus, with curved ends and formed from a single piece of marble, is carved with relief scenes illustrating the story of Jonah. There is disagreement as to whether its origins are Jewish or Early Christian, as there are several puzzling features in the carving. Jonah is shown sitting with his right hand extended, apparently speaking, and not – as is usual – lying down asleep, and the sailors on the boat are shown naked and working, rather than clothed and praying. On the ends of the sarcophagus are a sea-monster and a peacock, both under gourd trees. Peacocks and the story of Jonah itself allude to resurrection and immortality – appropriate subjects for a sarcophagus. Little is known of the history of the piece, although it may have been a Grand Tour acquisition. It was found in the garden of a house near Bath, in Somerset. Large holes have been drilled in the bottom, and were probably for drainage when it stood in the garden. The sarcophagus was purchased by the British Museum in 1957, with the help of the National Art Collections Fund.

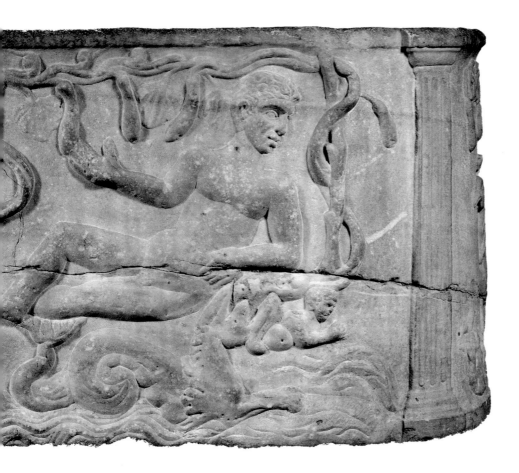

'It must be remembered that the style and department of art which Gainsborough chose, and in which he so much excelled, did not require that he should go out of his own country for the objects of his study; they were everywhere about him; he found them in the streets, and in the fields;... If Gainsborough did not look at nature with a poet's eye, it must be acknowledged that he saw her with the eye of a painter; and gave a faithful, if not a poetical, representation of what he had before him.'

Sir Joshua Reynolds, 'Discourse 14', *Discourses on Art*, 10 December 1790

The National Gallery, London
Acquired in 1960

MR AND MRS ANDREWS, 1750
Oil on canvas, 69.8 × 119.4
Thomas Gainsborough (1727–88)

Robert Andrews married Frances Carter at Sudbury, Suffolk – also Gainsborough's birthplace – on 10 November 1748. The costume clearly indicates a date of 1750, so it has been suggested that this may be a delayed marriage portrait. The painting remained in the Andrews family for several generations, and was not publicly seen until Mr W. G. Andrews loaned it to the Gainsborough bicentenary exhibition at Ipswich Museum in 1927. Thereafter it achieved popularity as one of three paintings widely reproduced to brighten up canteens on the home front during the Second World War, and the original was exhibited at the Festival of Britain in 1951. In 1960 the painting was purchased by The National Gallery, with the help of the National Art Collections Fund and other contributors.

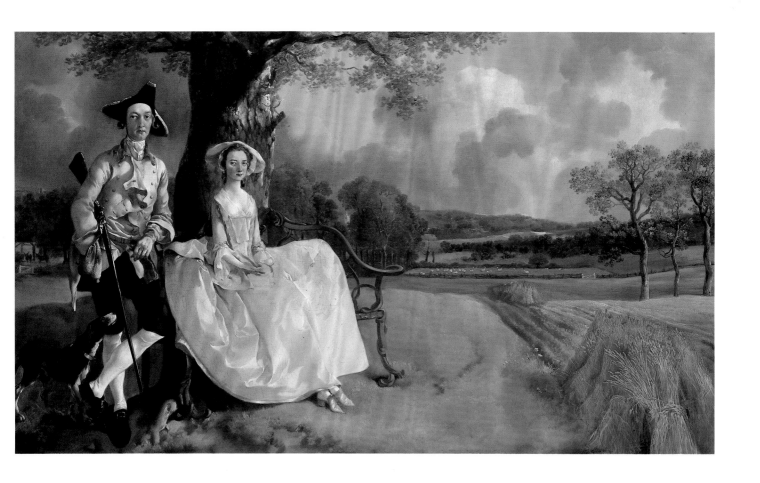

'He [Vuillard] is a sensitive and intelligent person and a highly strung, questioning painter. You feel that he has an unresting passion for art… His deftly noted interiors have great charm. He has a marvellous understanding of the timbre of things… The contrast of tone, the skilfully achieved chiaroscuro – these balance a scheme of colour which, though often grey and languid in effect, is always unusual and delicate – almost unhealthily so, in fact.

 The people in his pictures are not properly defined. As he's an admirable draughtsman it must be that he just doesn't want to give them mouths and hands and feet. His finished pictures are like sketches.'

Paul Signac, Diary 1898

Bristol City Museum and Art Gallery
Acquired in 1961

INTERIOR WITH MADAME HESSEL AND HER DOG, 1910
Oil on cardboard, laid on panel, 73.6 × 86.4
Edouard Vuillard (1868–1940)

Vuillard first met Madame Hessel and her financier husband in 1900, and for forty years the families were close friends. Vuillard travelled with the Hessels and spent a large part of every summer with them. He was among the many artists, writers, actors and actresses who frequented Madame Hessel's Paris salon, and he painted Madame Hessel on many occasions. This work, originally in a French private collection, was bought from Sir Alfred Chester Beatty's collection for Bristol City Musuem and Art Gallery, with the help of the National Art Collections Fund, in 1961.

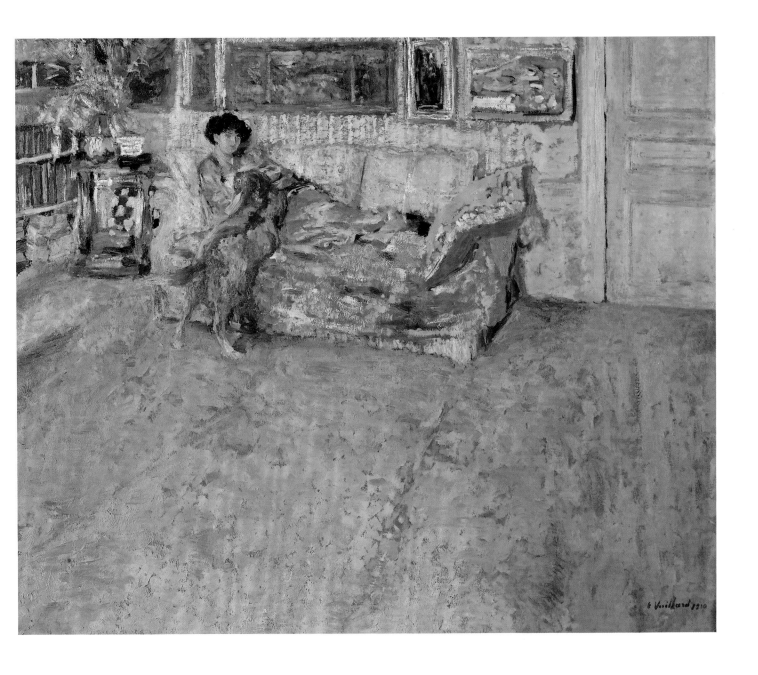

'Of the choice of beautiful faces. *It seems to me no small grace in a painter to be able to give a pleasing air to his figures, and this grace, if he have it not by nature, he may acquire it by incidental study in this way: Look about you to take the best part of many beautiful faces, of which the beauty is established rather by public fame than by your own judgement; for you may deceive yourself and select faces which bear a resemblance to your own, since it would often seem that such resemblance pleases us; and if you were ugly you would select faces that are not beautiful, and you would then create ugly faces as many painters do.'*

Leonardo da Vinci, Notebooks, late 15th century

The National Gallery, London
Acquired in 1962

THE VIRGIN AND CHILD WITH SAINT JOHN THE BAPTIST AND SAINT ANNE, 1490s
Chalk on paper, 141.5 × 104.6
Leonardo da Vinci (1452–1519)

The Leonardo cartoon, as this drawing is popularly called, is made up of several sheets of paper and appears to be a preliminary drawing for an unexecuted painting. Dating from the 1490s, it is thought to relate in some way to the painting of the same subject now in the Louvre. Its early history is unknown, but by 1779 the drawing was owned by the Royal Academy. When it became known in March 1962 that the Academy intended to sell the cartoon, a nationwide appeal was launched and administered by the National Art Collections Fund from an office within The National Gallery, staffed by volunteers. With enormous effort the requisite sum was raised within the six months available, and the drawing was duly purchased and presented to the gallery.

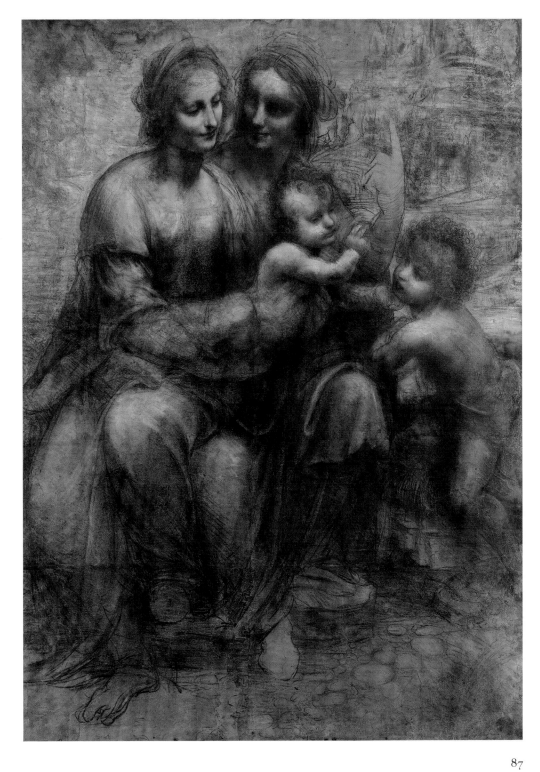

'...as soon as I had got to Mr. Laselles and look'd over the whole of ye house I found that [I] Shou'd want a Many designs & knowing that I had time Enough I went to York to do them, but before I Cou'd get all don I was taken Very ill of a Quinsey in My throat attended with fever...'

Thomas Chippendale, letter to Sir Rowland Winn, 19 July 1767

Temple Newsam House, Leeds
Acquired in 1965

LIBRARY WRITING TABLE, *c.* 1770
Oak, veneered with marquetry of various woods, ormolu mounts and handles,
84 × 207 × 120
Thomas Chippendale (1718–79)

Harewood House near Leeds was built from 1759 to 1771 by John Carr of York for Edwin Lascelles, later Lord Harewood. The interiors of the principal rooms were designed by Robert Adam, and Thomas Chippendale supplied lavish furniture from his London workshop for these rooms. The writing table was part of this commission – certainly the most valuable of Chippendale's career – which was executed from 1769 to 1777. The table remained at Harewood House until 1965, when its purchase for Temple Newsam House, Leeds, was assisted by a group of local benefactors, concerned that it should remain in the area, as well as by the National Art Collections Fund. Thomas Chippendale was born at Otley in Yorkshire, and retained his links with his birthplace until his death.

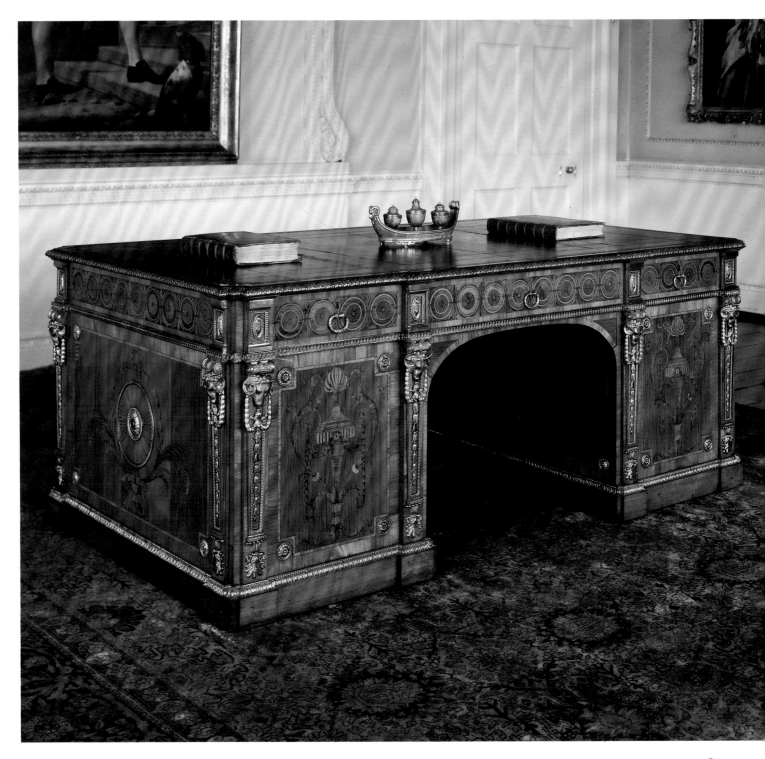

'We are informed from very good Authority; that there is now near finished a Statue of the justly celebrated Mr. Handel, exquisitely done by the ingenious Mr. Roubiliac, of St Martin's Lane, Statuary, out of one entire Block of white Marble, which is to be placed in a grand Nich, erected on Purpose in the great Grove at Vaux-hall-Gardens, at the sole Expense of Mr. Tyers, Undertaker of the Entertainment there; who in Consideration of the real Merit of that inimitable Master, thought it proper, that his Effigies should preside there, where his Harmony has so often charm'd even the greatest Crouds into the profoundest Calm and most decent Behaviour.'

London Daily Post, 18 April 1738

Victoria and Albert Museum, London
Acquired in 1965

GEORGE FREDERICK HANDEL (1685–1759), 1738
Marble, 135.3 high (excluding base)
Louis François Roubiliac (1705–62)

This strikingly informal statue shows Handel as Apollo, playing his lyre. The score of his recent success, *Alexander's Feast*, is among the books on which his left arm rests. The work was commissioned for Vauxhall Pleasure Gardens in London by the owner, Jonathan Tyers. After their glorious heyday in the 1740s and 1750s, the gardens failed, and finally closed down in the early nineteenth century. The statue descended through the Tyers family until it was sold in 1830. It was subsequently owned by the Sacred Harmonic Society, which specialised in performing Handel oratorios, and later by the music publishers, Novello and Company, in whose London office it stood until 1965, when it was purchased by the Victoria and Albert Museum with the help of the National Art Collections Fund.

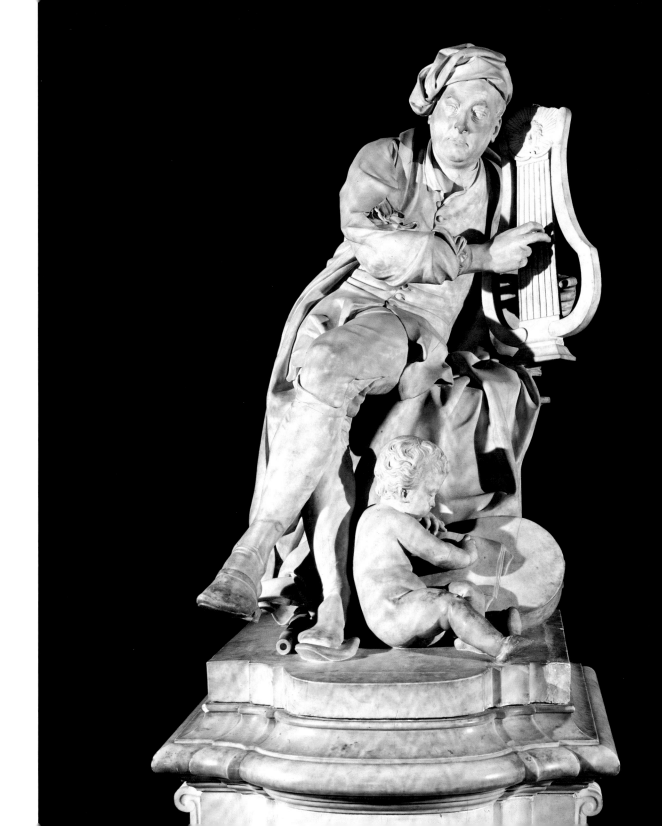

'Gwen John's apparent timidity and evasiveness disguised a lofty pride and an implacable will. When possessed by one of the "Demons" of whose intrusions she sometimes complained, she was capable of a degree of exaltation combined with ruthlessness which, like a pointed pistol, compelled surrender: but the pistol would be pointed at herself… Heroism knows no scruples.'

Augustus John, *Chiaroscuro: Fragments of Autobiography*, 1952

National Portrait Gallery, London
Acquired in 1965

SELF-PORTRAIT, *c.* 1900
Oil on canvas, 61 × 37.7
Gwen John (1876–1939)

For many years Gwen John, reticent and unassuming, was overshadowed by her flamboyant brother, Augustus John, and only quite recently has the calm sensitivity of her work become widely known and appreciated. This self-portrait was probably painted when she was living in London, after completing her training at the Slade School. She later went to live in Paris, where she modelled for Rodin, with whom she had a long and devoted relationship. The painting was originally owned by her brother, and was purchased from his widow by the Fund in 1965, when it was presented to the National Portrait Gallery to mark the eightieth birthday of Sir Alec Martin, and his forty years of service to the Fund.

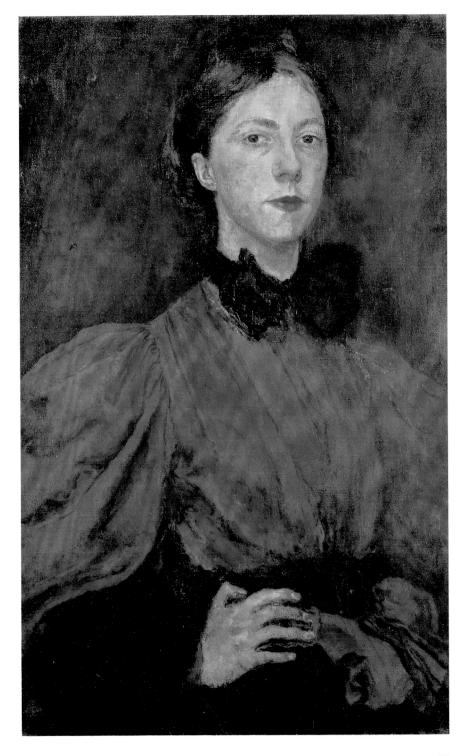

'He loved and did mightily strive to do somewhat of every Thing, and to excel in the most excellent; he greatly delighted in all Kind of rare Inventions and Arts, and in all Kind of Engines belonging to the Wars, both by Sea and Land: In the Bravery and Number of great Horses; in shooting and levelling of great Pieces of Ordinance; in the Ordering and Marshalling of Armes; in Building and Gardening; in all Sorts of rare Musick, chiefly the Trumpet and Drum; in Limming, Painting, and Carving, in all Sorts of excellent and rare Pictures, which he had brought unto him from all Countries.'

Sir Charles Cornwallis, *An Account of the Baptism, Life, Death and Funeral of…*
Frederick Henry, Prince of Wales, 1751

National Portrait Gallery, London
Acquired in 1966

HENRY, PRINCE OF WALES (1594–1612), *c.* 1610
Oil on canvas, 172.8 × 113.7
Robert Peake the Elder (*fl.* 1576–*c.* 1619)

Henry Frederick, the eldest son of James I and Anne of Denmark, was learned and cultivated, with wide-ranging interests which included riding, masques, literature, painting and music, but his greatest love was garden planning. Tragically, he died of typhoid fever at the age of eighteen. The distant view in this painting is probably of the garden at Richmond Palace, which was still being laid out for Henry by eminent designers, including one summoned from Florence, at the time of his death. The portrait was originally owned by the Prince's sister Elizabeth, later Queen of Bohemia (the 'Winter Queen'), and either she or her son, Prince Rupert, gave it to her devoted friend, William, 1st Earl of Craven. It remained in the Craven family until its purchase by private treaty sale by the National Portrait Gallery in 1966, with the help of the National Art Collections Fund.

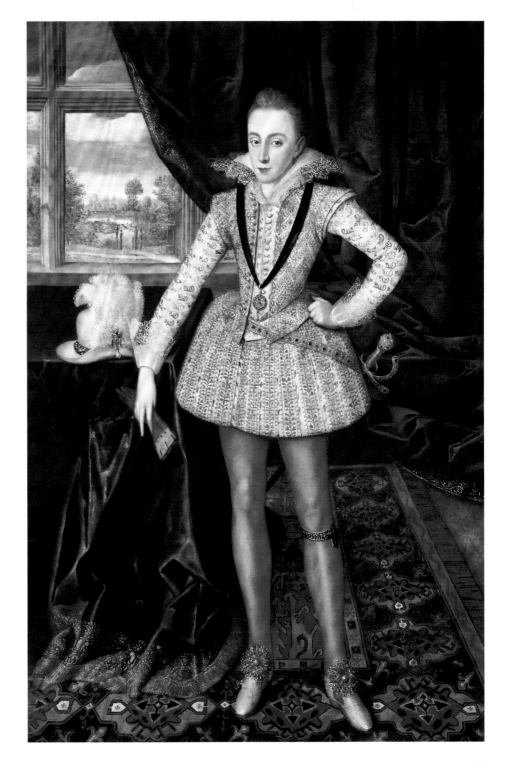

'...for nobody suspects Mr. Stubs of painting anything but horses &
lions, or dogs & tigers, & I can scarcely make anybody believe that
he ever attempted a human figure.'

Josiah Wedgwood, letter to his partner, Richard Bentley 25 September 1780

Manchester City Art Gallery
Acquired in 1970

CHEETAH AND STAG WITH TWO INDIANS, *c.* 1765
Oil on canvas, 180.7 × 273.3
George Stubbs (1724–1806)

Sir George Pigot started his career as a clerk with the East India Company in 1737, and
rose to be Governor-General of Madras. He made a great fortune in India, and in 1764
retired to England, where he bought an estate in Staffordshire. He brought back with him
a cheetah, accompanied, appropriately, by two trained Indian handlers. The animal was a
present for King George III, and was sent to the menagerie in Windsor Park, kept by the
King's brother, the Duke of Cumberland. It is thought that Pigot commissioned this
painting to record an event which took place on 30 June 1764, and which was reported in
several newspapers, intended to find out how the cheetah attacked its prey. The painting
remained in the Pigot family until 1970, when it was purchased by Manchester City Art
Gallery, with the assistance of the Fund.

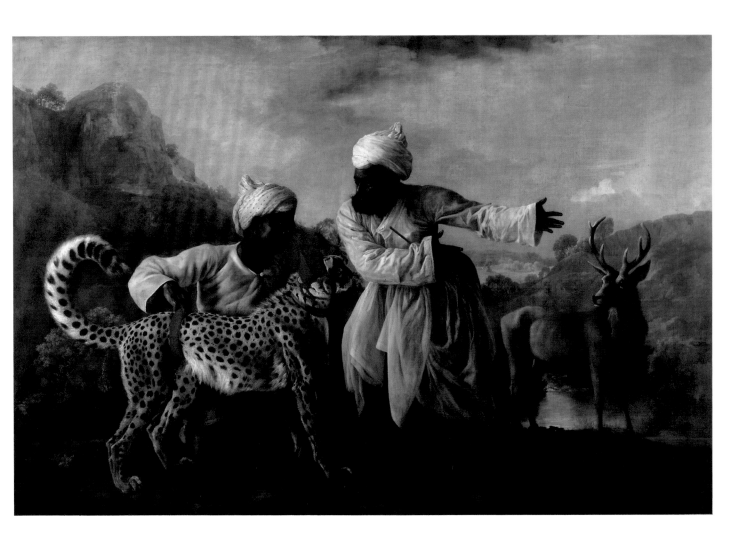

'…It is certainly true that the method used by Titian for painting these last pictures is very different from the way he worked in his youth. For the early works are executed with incredible delicacy and diligence, and they may be viewed either at a distance or close at hand: on the other hand these last works are executed with bold, sweeping strokes, and in patches of colour, with the result that they cannot be viewed from nearby, but appear perfect at a distance.'

Giorgio Vasari, 'Titian', *Lives of the Artists*, 1568

The National Gallery, London
Acquired in 1972

THE DEATH OF ACTAEON, late 1550s
Oil on canvas, 178.4 × 198.1
Titian (*c.* 1487/90–1576)

This painting was mentioned in a letter from Titian to Philip II of Spain in 1559, and recorded in the collection of Queen Christina of Sweden in Rome in 1661. It later passed to the Duke of Orléans in Paris and thence, during the French Revolution, to England, where it eventually became part of the collection of the Earls of Harewood. The work was sold to the Getty Museum, Malibu, in 1971, but a public appeal, which attracted support from many corporate and individual donors, the National Art Collections Fund and a special Exchequer grant, happily secured it for The National Gallery the following year.

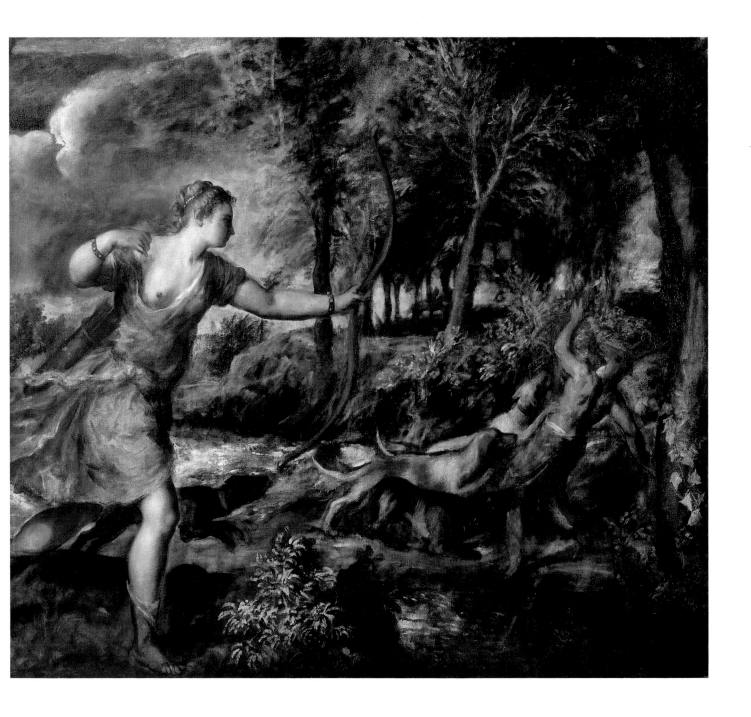

'She [Venus] has the face and aspect of a person who has had what the French call an "intimate" acquaintance with life; her companions, on the other hand, though pale, sickly, and wan, in the manner of all Mr Burne-Jones's young people, have a more innocent and vacant expression, and seem to have derived their langour chiefly from contact and sympathy.'

Henry James, review, *The Nation*, 1878

Laing Art Gallery, Newcastle upon Tyne
Acquired in 1972

LAUS VENERIS, 1873–5
Oil on canvas, 122 × 183
Sir Edward Coley Burne-Jones, Bt. (1833–98)

This famous painting, often considered to be one of Burne-Jones' most successful works, is closely related to a poem of the same title, written about ten years earlier by his friend, Charles Swinburne. The influences on both works range from the 'weariness of pain and bitterness of pleasure' expressed in Baudelaire's poetry, to the wandering knight of Richard Wagner's *Tannhäuser*. When first exhibited at the Grosvenor Gallery in 1878 the work attracted great attention – some approval and much virulent criticism. It was commissioned by William Graham, the great patron of Burne-Jones, who also owned a watercolour of the same subject. The work was purchased by the Laing Art Gallery of Newcastle upon Tyne in 1972, with the help of the National Art Collections Fund and other organisations.

'…But my most serious lapse was the failure to discover the genius of Seurat, whose supreme merits as a designer I had every reason to acclaim. I cannot even now tell whether I ever saw his work in the exhibitions of the early nineties, but if I did his qualities were hidden from me by the now transparent veil of pointillism – a pseudo-scientific system of atmospheric colour notation in which I took no interest.'

Roger Fry, 'Retrospect', *Vision and Design*, 1920

National Gallery of Scotland, Edinburgh
Acquired in 1973

FIELD OF ALFALFA, SAINT-DENIS, 1884–5
Oil on canvas, 64 × 81
Georges Seurat (1859–91)

Roger Fry's admiration of the work of Seurat, and particularly his purchase of this painting in the early 1920s, was important for the appreciation of the artist in this country. On Fry's death the picture passed to his daughter, from whom it was purchased (on generous terms, in memory of her father) in 1973 by the National Gallery of Scotland in Edinburgh, with the help of the National Art Collections Fund. Even toward the end of the last century, the area around Saint-Denis – now suburban Paris – was still open fields, which Seurat shows planted with alfalfa, but brightly bespeckled with poppies.

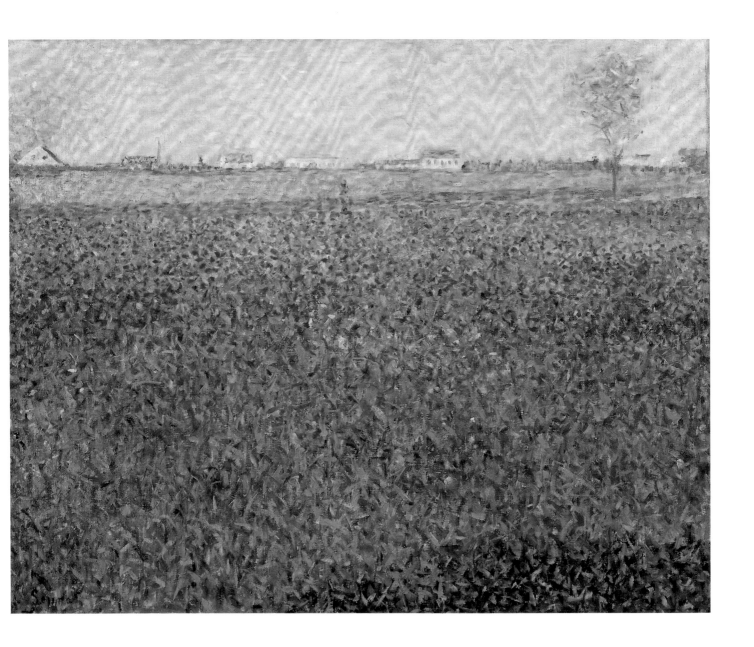

'...I have told Reid roundly that he made a foolish mistake in loving dead pictures and caring nothing for the living artists, and that moreover I hoped to see a change in him, at any rate on that score.'

Vincent van Gogh, letter to his brother Theo, 1888

Glasgow Art Gallery and Museum
Acquired in 1974

PORTRAIT OF ALEXANDER REID (1854–1928), 1887
Oil on board, 41 × 33
Vincent van Gogh (1853–90)

Alexander Reid, the son of a well-known Glasgow art dealer, went to Paris in 1886 or 1887 as an apprentice to the Paris art dealers, Boussod & Valladon, where Theo van Gogh also worked. Reid and the Van Gogh brothers were friends for a while, but the friendship was short-lived, probably due to Vincent's harsh criticism of Reid's taste in paintings. Reid returned to Glasgow, and was instrumental as a dealer in building up several of the private collections of French nineteenth-century paintings which later came to Glasgow Art Gallery and Museum. This portrait was never owned by Alexander Reid, but was purchased by his son in 1929, and bought by Glasgow Art Gallery and Museum from Reid's family in 1974, with the help of the National Art Collections Fund.

'Modest in his opinion of his own talents, he practised no tricks or
deception to obtain popularity, but as he loved his art fervently,
he practised it honestly, with indefatigable study and application…
His contemplative mind was employed in observing carefully,
inquiring minutely into, and reflecting continually on the subjects
around him, and thus comparing and adding the results of his own
observation, with the little he was taught, he gained perhaps as much
useful knowledge as is commonly acquired, in the ordinary way,
with greater assistance from books and masters.'

John Flaxman, 'Sketch of Romney's Professional Character', 1809

Abbot Hall Art Gallery and Museum, Kendal
Acquired in 1974

THE GOWER FAMILY, 1776–7
Oil on canvas, 203 × 232
George Romney (1734–1802)

George Romney started his career in Kendal, and although he moved to London, leaving
his wife behind in the north – perhaps feeling, as did Sir Joshua Reynolds, that 'marriage
spoilt an artist' – he eventually returned to Kendal and to that same wife, who nursed him
in his old age. This famous painting, which owes much to Romney's visit to Italy between
1773 and 1775, shows on the right Lady Anne, Lord Gower's daughter by his second
wife, Lady Louisa Egerton, and the four younger children of his third marriage to Lady
Susannah Stewart. The acquisition of the painting in 1974, with the help of the National
Art Collections Fund, was a major achievement for Abbot Hall, which is rightly acclaimed
as one of the best small museums in the country, and which in 1973 won the first
Museum of the Year award.

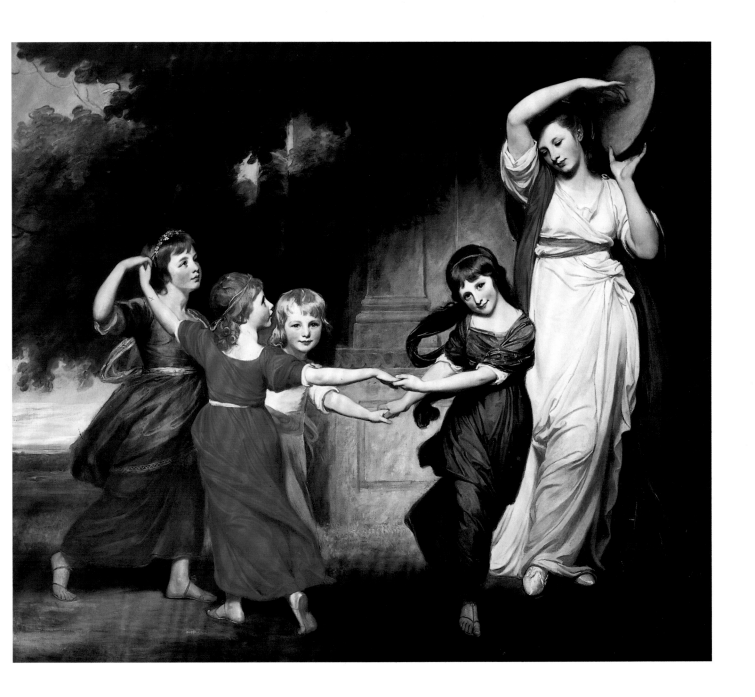

'Proceeding, then, to show to Prince Leopold the contents of the Museum, Mr. Ruskin first drew attention to the large picture of "The Madonna and Child" painted by Verrocchio, the master of Leonardo da Vinci, "given to me in Venice by a gracious fortune, to show to the people of Sheffield" – to whom, he explained, it was especially appropriate, since, besides being an unrivalled painter, Verrocchio was also a great worker in iron. Mr. Ruskin dwelt with enthusiasm on the teachings and technical merits of this picture… That picture, he said, was an answer to the inquiry often addressed to him, "What do you want to teach us about art?" It was perfect in all ways – in drawing, in colouring; on every part the artist had worked with the utmost toil man could give. He drew especial attention to the beauty and detail of the Virgin's girdle of embossed gold.'

Report on Prince Leopold's visit to the Walkley Museum,
Sheffield and Rotherham Independent, 23 October 1879

National Gallery of Scotland, Edinburgh
Acquired in 1975

MADONNA AND CHILD ('THE RUSKIN MADONNA'), *c.* 1470
Tempera on canvas, transferred from wood, 106.7 × 76.3
Attributed to Andrea del Verrocchio (*c.* 1435–88) and workshop

John Ruskin acquired this painting in 1877 from the Manfrini Collection in Venice for inclusion in the Museum of the Guild of St George in Sheffield. He had founded the guild in order, among other things, to promote the education of 'labourers and craftsmen' in science, art and literature. The museum was a large element in his scheme, and this painting was the start of the collection. It had earlier been attributed to Filippo Lippi, but Ruskin purchased it as by Verrocchio and his studio, and there was once a suggestion that the young Leonardo might have worked on it.

The painting was exhibited at Sheffield City Art Gallery from 1950 until its purchase in 1975 by the National Gallery of Scotland, with the help of the National Art Collections Fund. The proceeds of the sale helped to fund the establishment of the new Ruskin Gallery in Sheffield city centre in May 1985. Here Ruskin's collection is again on display, after being in store for many years. Prince Leopold (1853–84), Duke of Albany, was the fourth son (and eighth child) of Queen Victoria.

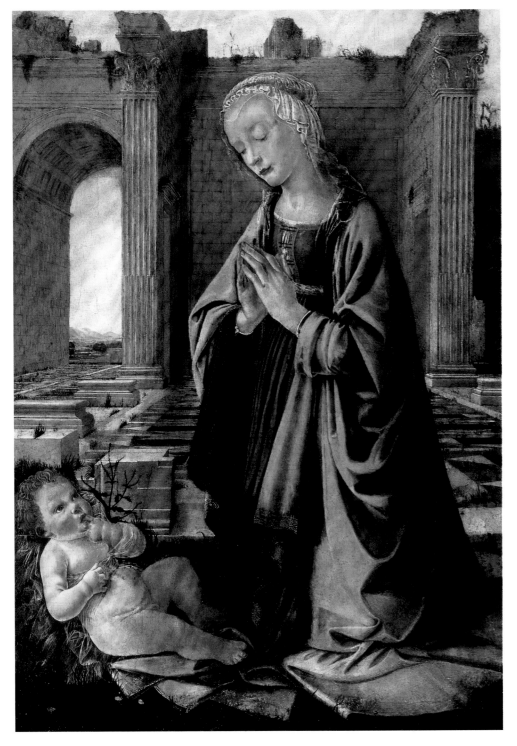

'Mackintosh's interiors achieve a level of sophistication which is way beyond the lives of even the artistically educated section of the population. The refinement and austerity of the artistic atmosphere prevailing here does not reflect the ordinariness that fills so much of our lives... At least for the time being, it is hard to imagine that aesthetic culture will prevail so much in our lives that interiors like these will become commonplace. But they are paragons created by a genius, to show humanity that there is something higher in the distance which transcends everyday reality.'

Herman Muthesius, *Das englische Haus*, 1904

Hunterian Art Gallery, University of Glasgow
Acquired in 1975

GUEST BEDROOM FURNITURE, 1919
Light oak, with stencilled and painted decoration
Charles Rennie Mackintosh (1868–1928)

This suite of furniture for the guest bedroom at 78 Derngate, Northampton, was commissioned by Whynne J. Bassett-Lowke, proprietor of the well-known engineering and modelmaking firm, as the final part of the remodelling of his Victorian terrace house. It was one of the few design commissions Mackintosh received after resigning his Glasgow partnership and moving to London in 1915. In spite of public acclaim in Europe, his work was never widely appreciated in Britain, and the last years of his life were dedicated entirely to watercolours. When the University of Glasgow reconstructed Mackintosh's Glasgow home as an integral part of its Hunterian Art Gallery, this furniture was put on permanent display in the Mackintosh Gallery. It was acquired with the help of the Fund in 1975, in memory of Professor Andrew McLaren Young, the originator and staunch protagonist of the project, who had died in that year.

'I record that on 27th August 1456, while I was treating Donato,
called Donatello, the singular and principal master in making figures
of bronze and wood and terracotta … he of his kindness and in
consideration of the medical treatment which I had given and was
giving him for his illness, gave me a roundel the size of a trencher in
which was sculpted the Virgin Mary with the child at her neck and two
angels on each side, all of bronze, and on the outer side hollowed out so
that melted glass could be cast onto it and it would make the same
figures as those on the other side.'

Giovanni Chellini Samminiati, *Libro debitori, creditori è ricordanze*, 27 August 1456

Victoria and Albert Museum, London
Acquired in 1976

THE CHELLINI ROUNDEL, mid—15th century
Bronze, 28.5 diameter
Donatello (*c.* 1386—1466)

Although this important documented Donatello roundel had been in a British private
collection since the eighteenth century, its location was not known until the roundel was
recognised when it was brought to the Victoria and Albert Museum in 1966 for an opinion.
When it came on to the market in 1975, the museum launched an appeal, with special
backing from the National Art Collections Fund in memory of the late Lord Crawford,
a former Chairman of the Fund, to purchase what was described as 'the most important
Italian fifteenth-century sculpture still in private hands'. It is now displayed in the museum
beside a marble bust, inscribed with the date 1456, by Antonio Rossellino of Chellini, the
doctor to whom Donatello gave the roundel in gratitude for being cured of a serious illness.
The roundel is designed so that casts in glass may be taken from the back of the relief —
an example is shown in the museum.

'But Giovanni Bellini has highly praised me before many nobles… And all men tell me what an upright man he is, so that I am really friendly with him. He is very old, but is still the best painter of them all.'

Albrecht Dürer, letter to his friend Wilibald Pirkheimer, from Venice, 7 February 1506

'Among the many rare things collected by their father, Christoforo and Francesco Muselli have two outstanding paintings by this artist [Giovanni Bellini]. One is in the form of an altarpiece showing the Queen of Heaven with Saint Peter and Saint Paul on either side and a donor at their feet, dressed in the classical manner, and on the cover Saint Francis and Saint Vincent Ferrer.'

Carlo Ridolfi, *Meraviglie dell'Arte*, 1648

Birmingham Museums and Art Gallery
Acquired in 1977

MADONNA AND CHILD ENTHRONED WITH SAINTS PETER AND PAUL AND A DONOR, 1505
Oil on poplar panel, 95.7 × 81.5
Giovanni Bellini (*fl.* 1459–1516)

This small altarpiece, which originally had closing doors, is signed and dated by Giovanni Bellini. It is thought to have been commissioned by a patron on the Venetian mainland for a private chapel. The donor's head, which is by a different hand, would have been left blank to be completed by a local painter. In 1648 the painting was recorded in the Muselli Collection in Verona, and by 1801 it was owned by the English collector, John Purling. By this time the doors had been removed and the work converted into a gallery painting. After changing hands several times it was acquired in 1899 by Vernon James Watney of Cornbury Park, Oxfordshire, and was on loan to Birmingham Museums and Art Gallery from 1967. When the painting came on to the market in 1977, the daunting task of raising the purchase price within a few months was addressed with extraordinary vigour. The National Art Collections Fund and the Friends of the Birmingham Museums and Art Gallery assisted, and among several large individual contributions was one from the art historian and collector Denis Mahon, given through the Fund, in memory of the late Lord Crawford's lifelong work for museums in Britain.

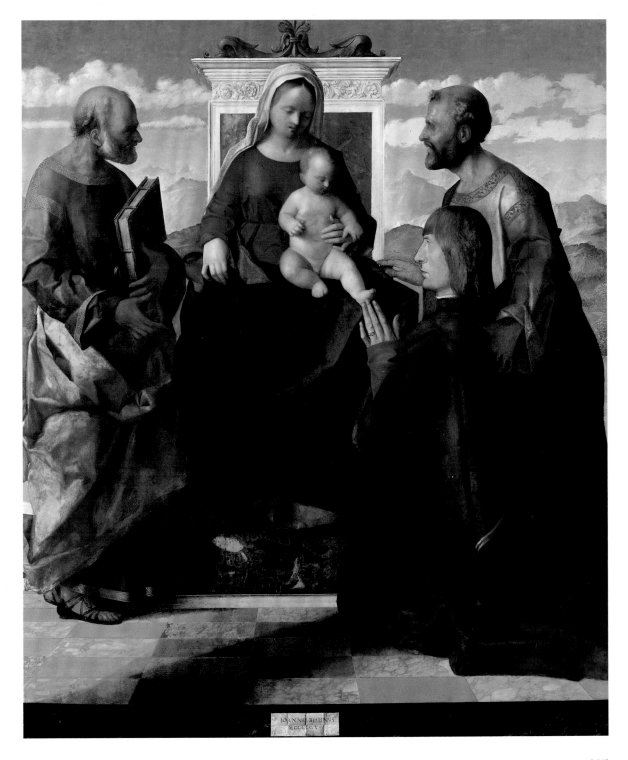

IOANNES BELLINVS
MCCCCCV

*'… the king called for a song from Fiammetta, who began to sing
most charmingly, as follows:*

*"If love could come unmixed with jealousy
Then there is not a living woman born
Who could be merrier than I would be."'*

Giovanni Boccaccio, *The Decameron, c.* 1349

Cartwright Hall, Bradford
Acquired in 1977

FIAMELLA, 1883
Oil on canvas, 61 × 46
John Atkinson Grimshaw (1836–93)

There has always been some uncertainty about the title of this painting, but it could be
the work exhibited in 1884 with the title *Fiametta*. As recorded by Boccaccio, Fiammetta
was one of the wealthy young Florentines who retreated to a villa outside the city during
the plague of 1348, and whiled away the time telling stories. It is possible that the subject
was suggested to Grimshaw by the first production of Franz von Suppé's opera *Boccaccio*
in 1882, and he is known to have painted at least one other subject from *The Decameron*.
Although Grimshaw is widely known for his moonlit townscapes and dock scenes, his
output included many portraits and works with classical themes. Grimshaw was born in
Leeds, and spent most of his life in the area, where his work was always much in demand.
It was, therefore, particularly appropriate that this painting should have been purchased in
1977 with the help not only of the Fund, but also of the Friends of the Bradford Art
Galleries and Museums Services.

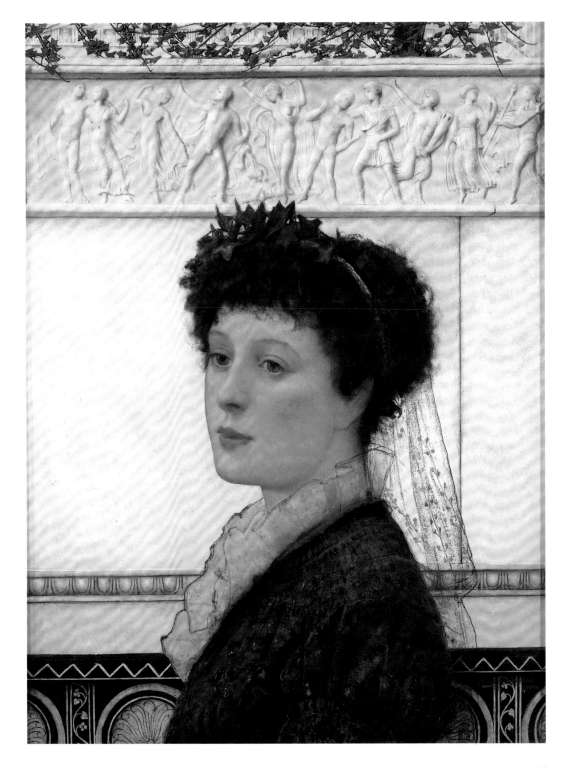

'There with fantastic garlands did she come,
Of crow-flowers, nettles, daisies, and long purples,
That liberal shepherds give a grosser name,
But our cold maids do dead men's fingers call them:
There, on the pendent boughs her coronet weeds
Clambering to hang, an envious sliver broke,
When down her weedy trophies and herself
Fell in the weeping brook.'

William Shakespeare, *Hamlet*, IV. vii. 169–76, *c.* 1601

The National Gallery, London
Acquired in 1977

OPHELIA AMONG THE FLOWERS, 1905–8
Pastel on paper, 64 × 91
Odilon Redon (1840–1916)

This vibrant pastel, purchased by The National Gallery with the help of the National Art
Collections Fund in 1977, is still one of the few examples of Redon's work in British public
collections. It is thought that the composition was originally a vase of flowers on a table,
but that Redon later turned the drawing on its side, and added the face and landscape.
Although Redon was frequently inspired by literature – in particular Baudelaire and
Flaubert – Shakespearian subjects are not common. He was, however, clearly fascinated
by the Ophelia theme, and another pastel and at least three oil paintings of the subject
are known.

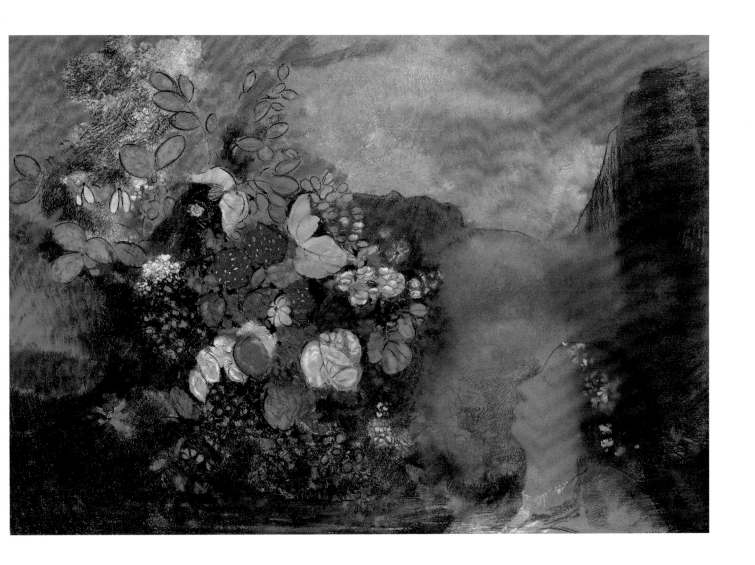

'The castle is a fine building, beautiful both by situation and its decoration; it stands on a solid rock of free-stone, from whose bowels it may be said to be built, as likewise is the whole town; the terrace of the castle, like that of Windsor, overlooks a beautiful country, and sees the Avon running at the foot of the precipice, at above 50 foot perpendicular height: the building is old, but several times repaired and beautified by its several owners, and 'tis now a very agreeable place both within and without. One finds no irregularity in the whole place, notwithstanding its ancient plan, as it was a castle not a palace, and built for strength rather than pleasure.'

Daniel Defoe, *A Tour through the Whole Island of Great Britain*, 1724–6

Birmingham Museum and Art Gallery
Acquired in 1978

WARWICK CASTLE — THE EAST FRONT, 1740s
Oil on canvas, 73 × 122
Giovanni Antonio Canal, called Canaletto (1697–1768)

This is one of five paintings and three drawings commissioned from Canaletto in the 1740s by Francis Greville, Lord Brooke, later Earl of Warwick. All were originally in the family's London residence, but were later transferred to Warwick Castle, where four paintings continued to be displayed until 1977, when they were sold by Lord Brooke, heir to the 7th Earl of Warwick. Two left the country, but a spirited fund-raising campaign launched by the Director of Birmingham Museum and Art Gallery, and supported by the National Art Collections Fund, happily saved the two views of the east front of the castle for the gallery, which is a mere twenty miles from Warwick.

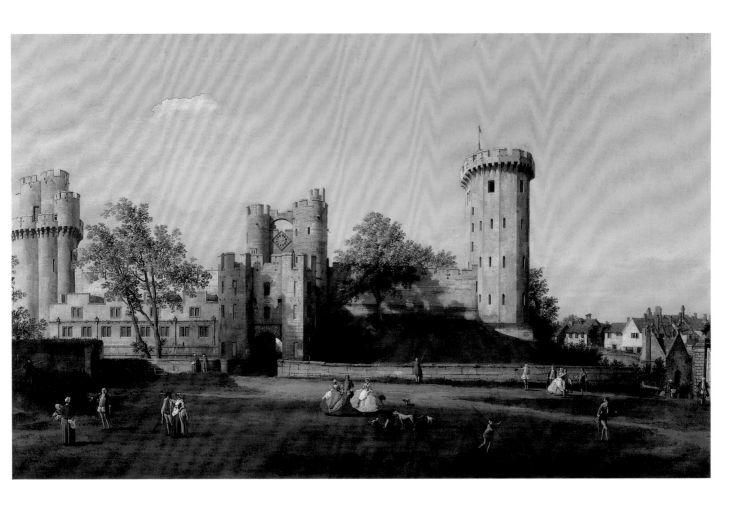

'Then, hanging an anchor about the saint's neck, he [the Emperor Trajan] cast him into the sea, saying: "At least the Christians will not be able to worship him as a god!" Then the whole multitude stood upon the shore, and Cornelius and Phoebus, Clement's disciples, ordered them to pray that the Lord might show them the body of His martyr. At once the sea receded to a distance of three miles, and walking over the dry bed, they came to a small house which the Lord had built in the fashion of a marble temple: and there, in an ark, lay the body of Saint Clement, and the anchor was at his side.'

Jacobus de Voragine, *The Golden Legend, c.* 1275

York City Art Gallery
Acquired in 1978

THE MARTYRDOM OF SAINT CLEMENT, *c.* 1500
Tempera and oil with gold on poplar panel, 42 × 63.5
Bernardino Fungai (1460–1516)

St Clement was Pope from *c.* AD 91–101, and the author of several important early Christian texts. *The Golden Legend* goes on to relate that some time after his martyrdom, the saint's body was taken back to Rome where it was enshrined at the church of St Clement, which, tradition claims, was built on the site of his house. This panel is probably from the predella of the *Coronation of the Virgin* altarpiece, executed by Fungai for the church of Santa Maria dei Servi (formerly dedicated to St Clement) at Siena, the artist's native town.

Another panel from the same predella, depicting *St Clement Striking the Rock*, was acquired by York City Art Gallery, through the National Art Collections Fund, in the Lycett Green bequest of 1955. It was therefore particularly fortunate that when this work came on to the market in 1978, the gallery was able to secure it with the help of the Fund, and the two panels were reunited. Furthermore, in 1991, the Fund helped the gallery to purchase the central predella panel, *Christ supported by Two Angels.*

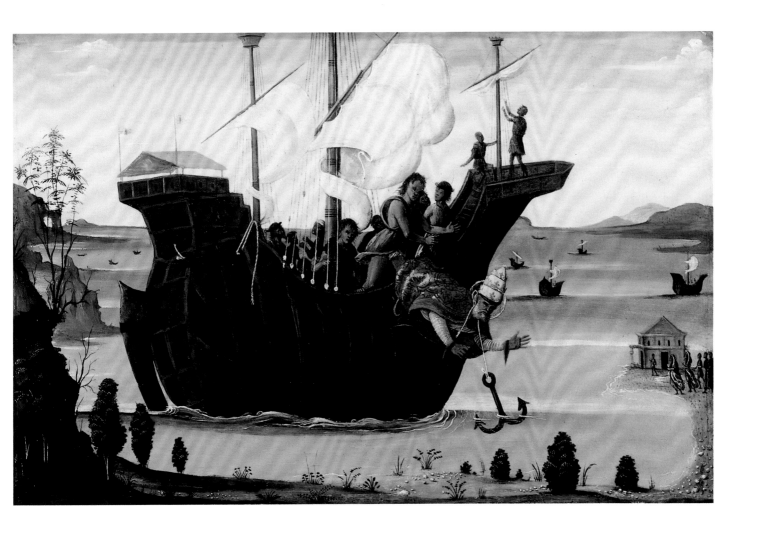

'When I first went into Sickert's show, ... I became completely and solely an insect – all eye. I flew from colour to colour, from red to blue, from yellow to green. Colours went spirally through my body lighting a flare as if a rocket fell through the night and lit up greens and browns... Colour warmed, thrilled, chafed, burnt, soothed, fed, and finally exhausted me.'

Virginia Woolf, *Walter Sickert: a Conversation*, 1934

'Did he realise that whether he willed it or by chance, in spite of himself, he was to be the painter of Dieppe? No other artist has so perfectly felt and expressed the character of the town, whose Canaletto he has become.'

Jacques-Emile Blanche, *Portraits of a Lifetime*, 1937

Aberdeen Art Gallery and Museum
Acquired in 1979

THE BASKET SHOP, RUE ST JEAN, DIEPPE, 1911–12
Oil on canvas, 50.2 × 60.9
Walter Richard Sickert (1860–1942)

In 1900 Alexander Macdonald, a local granite merchant, bequeathed a number of contemporary paintings to Aberdeen Art Gallery and Museum, with an endowment specifying that it be used only to purchase works painted within the last twenty-five years. This formed the basis of an important collection of early twentieth-century British and European paintings, which has grown steadily over the years. The gallery already owned several works by Sickert, but none of Dieppe before the purchase of this painting, which had been in a private collection in Scotland for some years. In 1979 it was secured for the gallery with the help of the National Art Collections Fund.

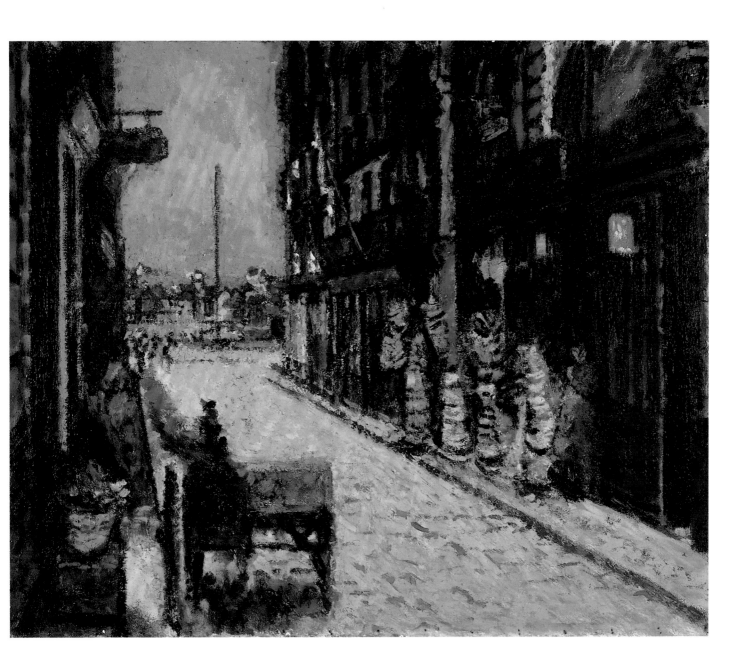

'Baron Denon waited upon us, and conducted us over his exhibition of extraordinary antique curiousities, also the Louvre, Marshal Soult's pictures &c. I expected that I should have seen in the Louvre some very large metallic bronze vases, somewhat in accordance with the one at Warwick Castle, of which I had much conversation with the Baron… He observed that it was a singular fact that in all his travels in Egypt, Greece, Italy &c. he knew not of one of any magnitude; and remarked that had the Emperor Buonaparte been successful in conquering England, which many of the French generals presumed upon, the first note entered in his pocket-book was to possess himself of the marble vase at Warwick Castle.'

Sir Edward Thomason (who had cast the vase in iron), on a visit to Paris where he met Baron Denon, Napoleon's adviser on works of art, May 1814

Burrell Collection, Glasgow
Acquired in 1979

THE WARWICK VASE, AD 1st–2nd century (heavily restored in the 18th century)
Marble, 294 high (including pedestal) 195 diameter

This enormous Roman vase was discovered in fragments at Hadrian's Villa at Tivoli in 1771 by the Scottish artist and antiquary Gavin Hamilton. It was bought, restored – probably under the supervision of Piranesi – and shipped to England by Sir William Hamilton. Having failed to persuade the British Museum to buy the vase, he sold it to his nephew, the Earl of Warwick. The vase has always excited great interest, and soon became widely known and highly influential through engravings and copies in iron and bronze (although an ambitious scheme for a silver copy was never realised). *The Warwick Vase* stood in a conservatory at Warwick Castle until its sale to a foreign buyer in 1979. The export was opposed, and it is appropriate, since two Scotsmen were responsible for its survival, that with the help of the Fund the vase was purchased for Glasgow, and displayed in the newly opened Burrell Collection.

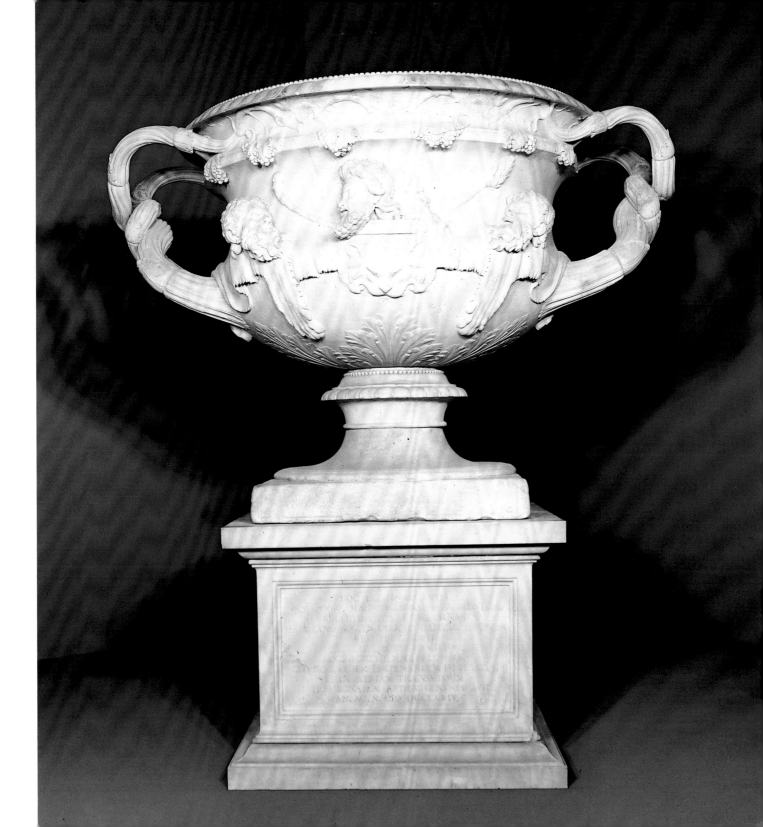

'My Heavenly Father took pains to order me to follow his will. Thus, beloved mother, I must go to Jerusalem. You shall stay with your friends and pass your time with them. I will divert your suffering and will set you in my kingdom on a throne that is prepared for you. There you will be a light of Christianity. Thus I give you my blessing – may the Heavenly Father preserve thee.'

Augsburg Passion Play, 15th century

'As a painter, Altdorfer, besides his homely dramatic ingenuity and sense of the picturesque, exhibits a really admirable mastery and richness of colour; his weak point in art of this serious scale and difficulty is draughtsmanship, his practice in the miniature style not having taught him to draw large figures correctly. A good instance of both the faults and excellences of his painting is the Christ taking leave of his Mother...'

Sir Sidney Colvin, 1877

The National Gallery, London
Acquired in 1980

CHRIST TAKING LEAVE OF HIS MOTHER, *c.* 1520
Oil on limewood panel, 141 × 111
Albrecht Altdorfer (*c.* 1480–1538)

This is one of the most famous works by Altdorfer, who, possibly as a result of the impression made upon him by his early travels along the Danube and in the Austrian Alps, depended largely on landscape to create the mood of his paintings. Few of his works survive, and most of those that do are in German or Austrian collections. Probably painted for a church in Regensburg, Bavaria, in about 1520, this painting was recorded in a German collection in 1819, and by 1850 was with the English theologian and collector, the Rev. John Fuller Russell. In 1904 the painting was acquired by Sir Julius Werner for Luton Hoo. It remained there until 1980, when it was purchased by The National Gallery with the help of the National Art Collections Fund and other organisations.

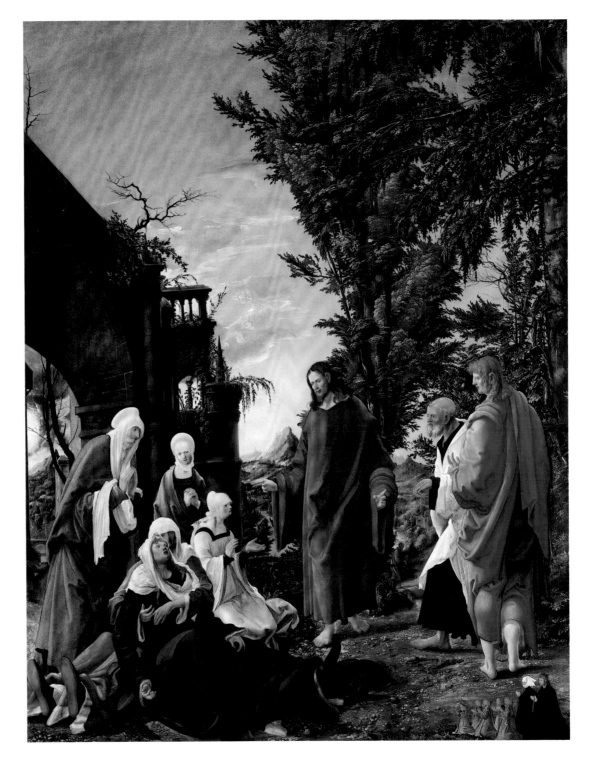

'I think that artists can in fact help one another... I've always thought of friendship as where two people really tear one another apart and perhaps in that way learn something from one another...

Even in the case of friends who will come and pose, I've had photographs taken for portraits because I very much prefer working from the photographs than from them... I find it easier to work than actually having their presence in the room. I think that, if I have the presence of the image there, I am not able to drift so freely as I am able to through the photographic image. This may be just my own neurotic sense but I find it less inhibiting to work from them through memory and their photographs than actually having them seated there before me.'

Francis Bacon, interview with David Sylvester, May 1966

Whitworth Art Gallery, University of Manchester
Acquired in 1980

PORTRAIT OF LUCIAN FREUD, 1951
Oil on canvas, 198 × 137
Francis Bacon (1909–92)

The pose of this early portrait of Lucian Freud, a long-time friend of Francis Bacon, is said to have been inspired by a photograph of Franz Kafka which was used as the frontispiece for Max Brod's biography of the writer. It has also been suggested that Bacon intended to draw a parallel between the existentialist novelist and Freud, the drifting, rootless artist. Not only was a photograph the inspiration, but Bacon preferred to work from photographs without the sitter being present. Purchased in 1980 with the help of the Fund, this was the first work by Bacon to enter the collection of the Whitworth Art Gallery, which has been steadily building up its holding of twentieth-century British drawings and paintings.

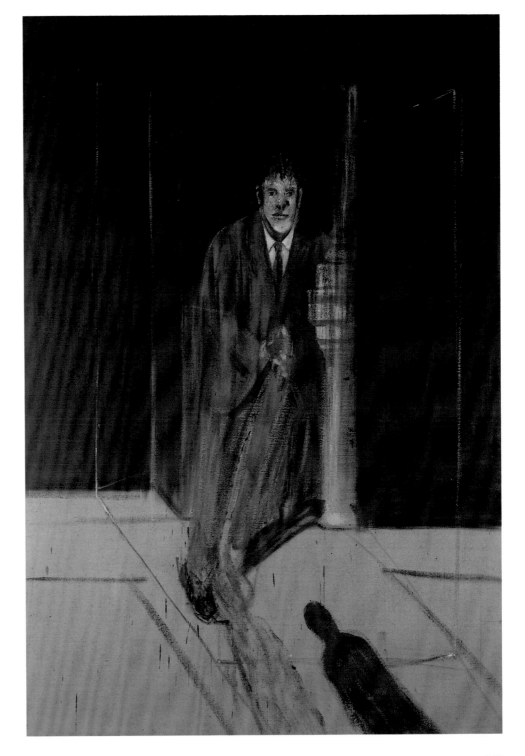

'…Pan was boasting to the gentle nymphs, singing them his songs, and playing some trivial tune on the reeds, joined by wax, that formed his pipes. As he did so, he had the audacity to speak slightingly of Apollo's music, compared with his own, and entered into unequal competition with the god, in a contest to be decided by Tmolus… Apollo had wreathed his golden hair with laurel from Parnassus… His very stance was that of a musician. Then he plucked the strings with skilful fingers till Tmolus, enchanted by the sweetness of the melody, bade Pan admit his pipes inferior to the lyre.'

Ovid, *Metamorphoses*, XI. 153–72, *c.* AD 2–10

Fitzwilliam Museum, Cambridge
Acquired in 1981

THE CONTEST BETWEEN APOLLO AND PAN, 1599
Oil on copper, 25.2 × 33.9
Hans Rottenhammer (1564–1625) and Jan Brueghel the Elder (1568–1625)

Hans Rottenhammer from Germany and Jan Brueghel from the Netherlands met in Rome in about 1593 and worked together on several small paintings on copper, in which Rottenhammer painted the figures and Brueghel the landscapes. Although this particular work, painted in Venice in 1599, is signed only by Rottenhammer, the landscape is clearly the work of Jan Brueghel. The painting was purchased by the Fitzwilliam Museum in 1981 with the help of the National Art Collections Fund, to join a group of works by northern artists working in Italy at this time – Elsheimer, Liss and, of course, Rubens, friend and one-time collaborator with Jan Brueghel.

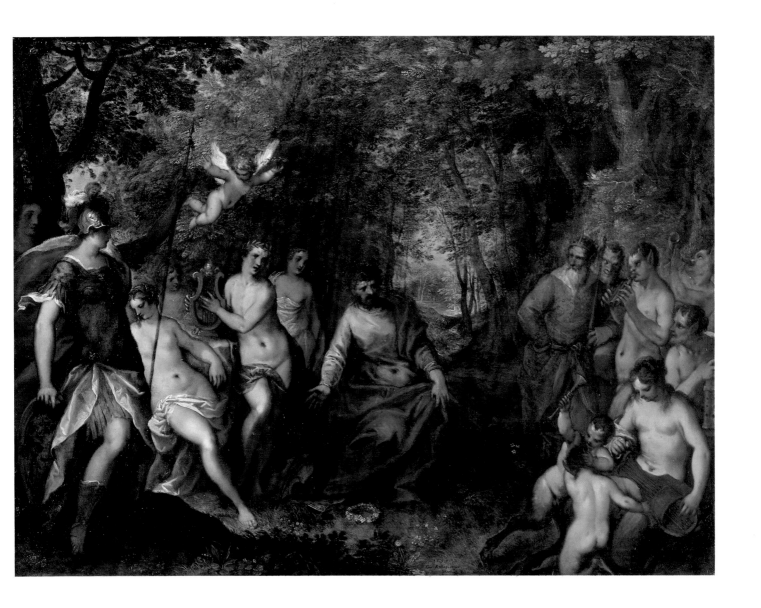

'You know the Enchanted Castle it doth stand
Upon a Rock on the Border of a Lake
Nested in Trees, which all do seem to shake
From some old Magic like Urganda's sword…
 You know it well enough, where it doth seem
A mossy place, a Merlin's Hall, a dream.
You know the clear lake and the little Isles,
The Mountains blue and cold near neighbour rills –
All which elsewhere are but half animate
Here do they look alive to love and hate;
To smiles and frowns; they seem a lifted mound
Above some giant, pulsing underground.'

John Keats, 'To John Hamilton Reynolds, Esq.', 25 March 1818

The National Gallery, London
Acquired in 1981

LANDSCAPE WITH PSYCHE OUTSIDE THE PALACE OF CUPID ('THE ENCHANTED CASTLE'), 1664
Oil on canvas, 87 × 151
Claude Gellée (Le Lorrain) (1600–82)

The subject of this painting is taken from the story of Psyche told by Apuleius in *The Golden Ass*. There is uncertainty as to the part of the story depicted, but the mood of sorrow and melancholy suggests ill-fated love. Psyche is possibly shown grieving after Cupid has abandoned her. It was painted in 1664 for Claude's patron, Lorenzo Onofrio Colonna, and a pendant, *Psyche saved from drowning herself*, is in Cologne. The picture has been in England since the eighteenth century, when it received its more romantic title through an engraving, which was probably how Keats first came to know of it. It was acquired by The National Gallery in 1981 with the help of the National Art Collections Fund, by private treaty sale from the Loyd Collection, to which it had belonged since 1850.

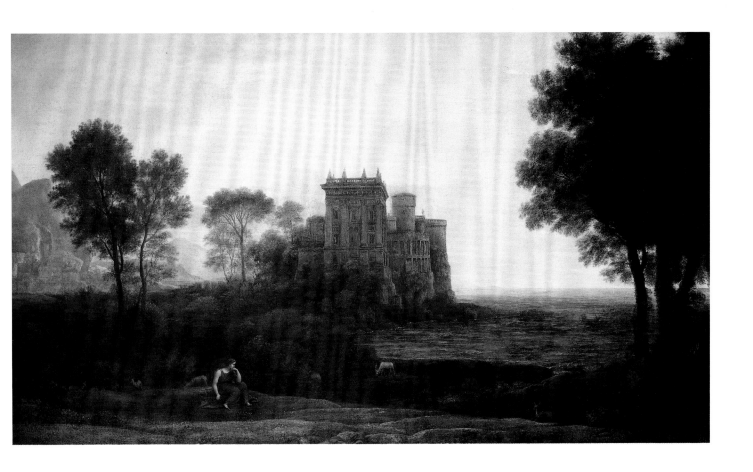

'The following morning I left Liverpool for Ince, the seat of Mr Blundell Weld … who … received me not only with kindness, but invited me to remain his guest at Ince as long as a leisurely inspection of his works of art might require …

… here is a most attractive work. The Virgin, enthroned beneath a canopy, is gazing with a most graceful action upon the Child sleeping on a cushion in her lap, holding an apple. She is taking some cherries with her right hand out of a basket which an angel is extending to her. On the other side are three singing angels, the one with the music-book very graceful. At the sides of the canopy are views on to a rich landscape. This picture is executed with the most singular transparency and delicacy, and is in excellent preservation.'

Dr Gustav Waagen, *Treasures of Art in Great Britain*, 1854

Walker Art Gallery, Liverpool
Acquired in 1981

VIRGIN AND CHILD WITH ANGELS, *c.* 1520
Oil on panel, 85 × 65.5
Joos van Cleve (*fl.* 1511–40/41)

The purchase of this early work of Joos van Cleve, with the help of the National Art Collections Fund in 1981, was a valuable addition to the collection of paintings by early Northern European artists at the Walker Art Gallery. The local connections of the painting were also of significant interest. It came from Ince Blundell Hall, near Liverpool, where Henry Blundell (d.1810) and his son, Charles (d.1837), were among the first connoisseurs in England of the early Italian and Northern schools of painting. The gallery already owned other works from this important local collection.

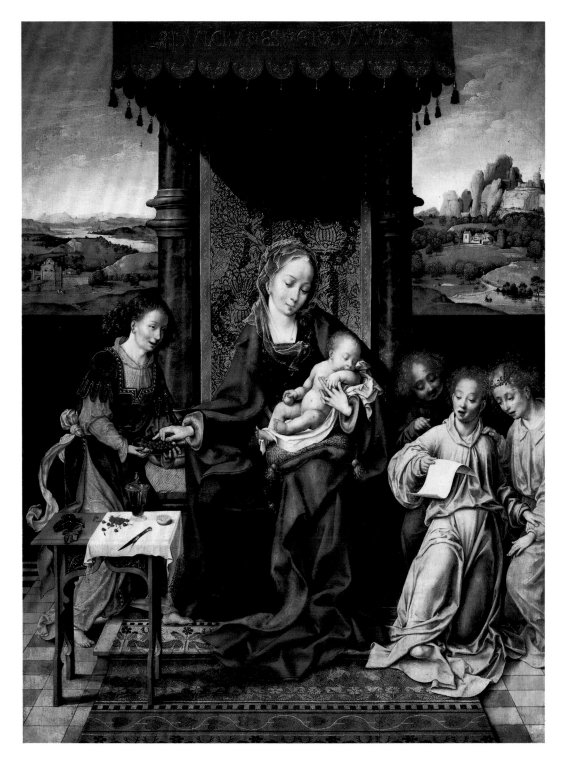

*'I have such a passion for painting! I am continually working at form.
In actual drawing, and in my head, and during my sleep. Sometimes
I think I shall go mad, this painful, sensual pleasure tires and torments
me so much. Everything else vanishes, time and space, and I think of
nothing but how to paint…'*

Max Beckmann, letter to his wife from the Front during the First World War, 11 May 1915

*'To transform three into two dimensions is for me an experience full of
magic in which I glimpse for a moment that fourth dimension which my
whole being is seeking…'*

Max Beckmann, *On My Painting*, 1938

Tate Gallery, London
Acquired in 1981–2

CARNIVAL, 1920
Oil on canvas, 186.4 × 91.8
Max Beckmann (1884–1950)

Beckmann's experiences in a typhus hospital during the First World War caused a
breakdown which marked him for life and radically changed his painting style. He was
discharged from the German Army Medical Corps in 1915 and went to live in Frankfurt
with an artist friend, Ugi Battenberg, to recover his health. It was there that he painted
Carnival. Battenberg's wife Fridel is shown dressed as a pierrette on the right of the
painting, on the left is Beckmann's dealer, and the artist himself, masked and dressed as a
clown, lies at the feet of the couple. This is one of several versions of a subject which
constantly fascinated Beckmann. The painting was first owned by his dealer, Israel der
Neumann, and was purchased by the Tate Gallery in 1981–2 with the help of the
National Art Collections Fund and the Friends of the Tate Gallery.

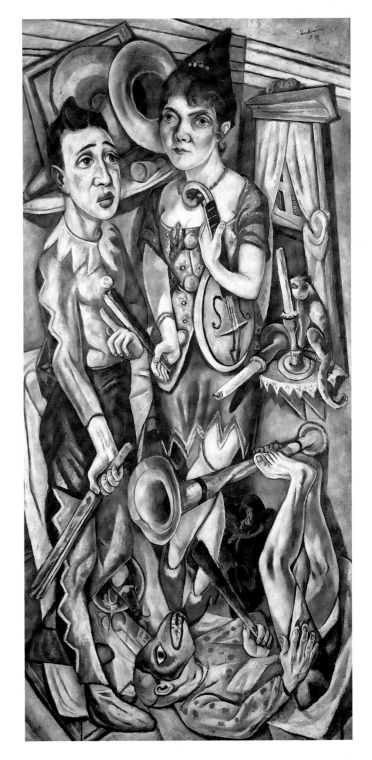

'...[Bellotto] having some Genius was instructed by his uncle Cannali and this young stripling by degrees came on forward in his proffession ...but in time getting some degree of merrit, he being puff'd up disobliged his uncle who turned him adrift. But well Imitating his uncles manner of painting became reputed and the name of Cannaletti was indifferently used by both uncle and nephew ... so that this caused the report of two Cannalettis.'

George Vertue, Notebooks, 1749

Manchester City Art Gallery
Acquired in 1982

A VIEW OF THE CASTLE OF KÖNIGSTEIN, SAXONY, *c.* 1756–8
Oil on canvas, 132.1 × 236.2
Bernardo Bellotto (1720–80)

Bellotto, nephew and pupil of Canaletto, appears to have quarrelled with his uncle in the mid-1740s and, separately, they left their native Venice. Whilst Canaletto came to England, Bellotto travelled in Italy before going to Dresden in 1747. The following year he was appointed court painter to the Elector Augustus II of Saxony – later Augustus III of Poland – for whom he painted many views, of which this work is typical. Bellotto's detail and accuracy is such that his paintings of Warsaw were used to assist in the reconstruction of the city after the Second World War. It is not known when or how his two views of Königstein now in Manchester came to England, but in 1778 they were purchased by an ancestor of the 1982 vendor. This painting was purchased by Manchester City Art Gallery in 1982 with the help of the National Art Collections Fund, and the second view of Königstein was acquired by the gallery a year later.

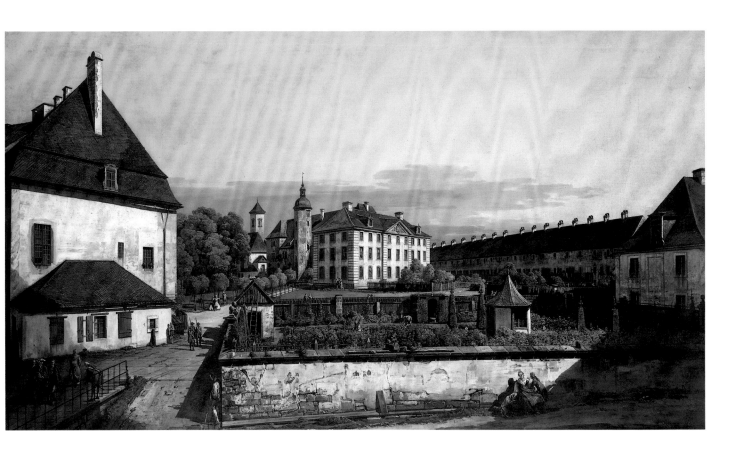

'But the great feature of our medieval chamber is the furniture; this in a rich apartment would be covered with paintings both ornaments and subjects; it not only did its duty as furniture but spoke and told a story.'

William Burges, 'Furniture', *Art Applied to Industry*, 1865

Cecil Higgins Art Gallery and Museum, Bedford
Acquired in 1982

PAINTED WARDROBE, 1875
Painted wood, 188 × 119.5 × 71
William Burges (1827–81)

The Cecil Higgins Art Gallery and Museum purchased Burges' own scarlet bed and dressing table from the Handley-Read Collection in 1972, and created a Burges room decorated by a firm (Campbell, Smith & Co., established in 1873) which had worked for the designer himself. This wardrobe, with typical quirky humour, depicts Adam's reclothing after his expulsion from Eden, as well as a hair brush, comb, mirror, razor and so on. It was designed for Burges' own use, presumably to hold clothes, although the hinged drawers – only 36 centimetres wide – do not appear to be very practical. The purchase of the wardrobe by the gallery in 1982, with the help of the National Art Collections Fund, further enriched its Burges collection.

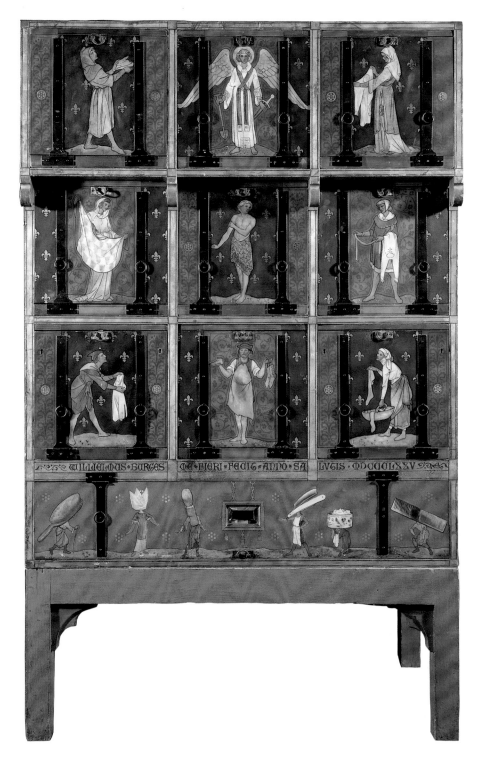

'The Marks or Ensigns of Virtues contribute not little by their nobleness to the Ornament of the Figures. Such, for example as are the Decorations belonging to the Liberal Arts, *to* War, *or* Sacrifices. *But let not the work be too much enrich'd with Gold or Jewels, for the abundance of them makes them look cheap, their Value arising from the Scarcity.'*

C. A. du Fresnoy, *The Art of Painting*, 1668

Ashmolean Museum, Oxford
Acquired in 1982

PORTRAIT OF A YOUNG MAN, 1561
Oil on canvas, 133 × 104
Alessandro Allori (1535–1607)

That Alessandro Allori was a pupil of the Florentine Mannerist painter, Bronzino, is clearly reflected in the refinement and polish of this early portrait. Indeed, the work, acquired in the mid-nineteenth century by Baron Mayer Amschel de Rothschild, appeared in the catalogue of his collection at Mentmore as a portrait of Benvenuto Cellini by Bronzino. The painting remained in the family until the Mentmore sale of 1977, when an American buyer purchased it. However, an export licence was withheld. The work was loaned to the Ashmolean Museum for some years, and when it came on to the market again in 1982, the museum was able to purchase it with the help of the Fund, as a fitting complement to the Italian Mannerist works already in its collection.

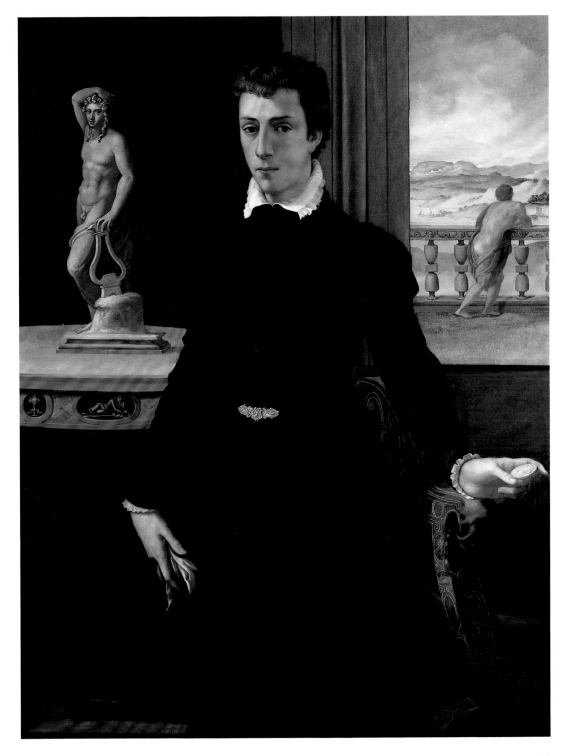

'I take upon myself the burden of all suffering, I am resolved to do so, I will endure it. I do not turn or run away, do not tremble, am not terrified, nor afraid, do not turn back or despond.

The whole world of living beings I must rescue, from the terrors of birth, of old age, of sickness, of death and rebirth, of all kinds of moral offence, of all states of woe, of the whole cycle of birth-and-death, of the jungle of false views…from all these terrors I must rescue all things.'

Sikshasamuccaya, 280 (Vajradhvaja Sutra), AD 7th century

Ashmolean Museum, Oxford
Acquired in 1982

A SEATED BODHISATTVA, late 13th century
Fig wood with traces of polychrome decoration, 173 high
Northern China

In Mahayana Buddhism, Bodhisattvas are those who have attained Nirvana, but choose to remain in contact with this world in order to help others in their quest for the same state. This figure represents Avalokitesvara, originally an Indian god of mercy, who intercedes with Buddha on behalf of mortals. In the transition to China confusion has arisen, and the god has changed sex – Chinese versions of the figure often show her with a child in her arms. This example is made of fig wood and was originally brightly painted; it was repainted and lacquered at various times, but there are only slight traces of colour now visible. It was found in the Chinese countryside in the 1930s by a Peking art dealer, who moved it to Paris with his collection of Chinese works of art. An American collector bought the figure, and on his death in 1981 it was sold at auction and acquired by the Ashmolean Museum, assisted by the National Art Collections Fund.

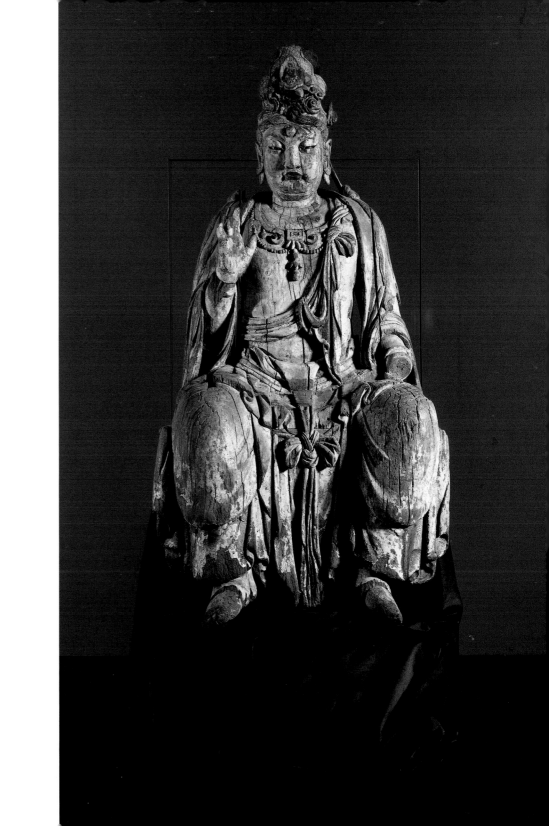

'Forty years have passed since we saw this picture yet we could almost describe from memory the lurid red of the setting sun, the broken waves of the subsiding storm, the few survivors of the wreck, alone on a raft on the limitless ocean.'

Sir Richard Redgrave, *A Century of Painters of the English School*, 1866

'The fact is, Sir Thomas [Lawrence] felt it a disgrace to Art that a picture like the "Sunset" should be unsold at £50, and liberally paid Danby £100 for it.'

J. Hogarth, letter, *Art Journal*, 1 October 1860

Bristol City Museum and Art Gallery
Acquired in 1982

SUNSET AT SEA AFTER A STORM, 1824
Oil on canvas, 89.6 × 142.9
Francis Danby (1793–1861)

When this painting was exhibited at the Royal Academy in 1824, it astonished the reviewers who had previously not favoured Danby. It was purchased from the artist by the President of the Royal Academy, Sir Thomas Lawrence, on whose advice Danby later said he had moved to London – though his debts in Bristol were also certainly a factor. This work is said to have made Danby's reputation. Although at the time he had not yet seen Géricault's famous *Raft of the Medusa* (1819), Danby knew it from descriptions, and it is thought to have influenced him greatly. *Sunset at Sea after a Storm* was purchased in 1982 with the help of the Fund by the art gallery in Bristol, the city where Danby lived for eleven years and in which the picture was painted.

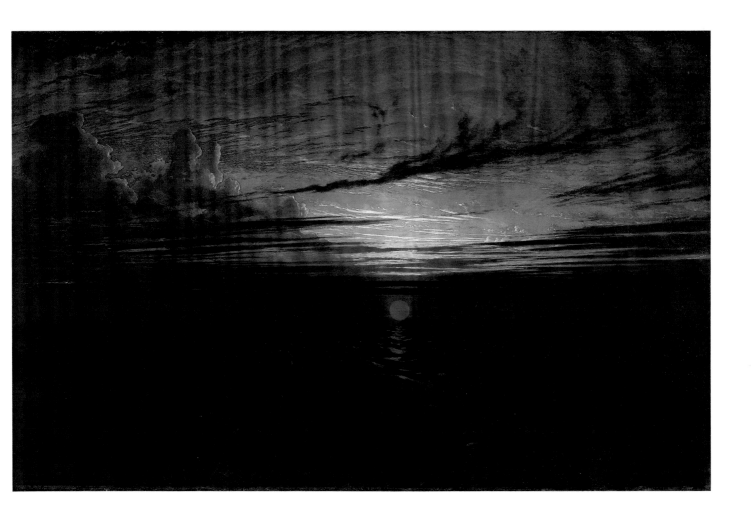

'These were still the days of struggle [c.1910], and I was far from satisfied with what I was doing. My aim was to perfect myself in modelling, drawing and carving, and it was at this period I visited the British Museum, and whenever I had done a new piece of work I compared it mentally with what I had seen at the Museum. These rich collections are rarely visited by sculptors. You could pass whole days there and never come across a sculptor. It would be considered a lack of originality to be discovered there. Fancy a dramatist or poet willingly eschewing Shakespeare and the Elizabethans, or a composer of music deliberately avoiding Bach and Beethoven!'

Sir Jacob Epstein, *Let there be sculpture: An Autobiography*, 1940

Leeds City Art Gallery
Acquired in 1983

MATERNITY, 1910–11
Hoptonwood stone, 208.2 high
Sir Jacob Epstein (1880–1959)

Maternity has been described as the first modern sculpture in England to have been inspired by 'primitive' art. The voluptuous pose and calm facial features are reminiscent of Hindu sculpture, examples of which the sculptor would have seen on his visits to the British Museum. Epstein was fascinated by the idea of motherhood, and returned to it in his works on several occasions. This figure, exhibited in 1911 in its unfinished state, was especially influential on young British sculptors because the roughly cut sides and rear of the skirt demonstrated Epstein's experimental technique of direct carving.

 Maternity remained in Epstein's possession until his death. It was purchased with the assistance of the Fund by Leeds City Art Gallery in 1983 from an American private collector for the newly opened Moore Sculpture Gallery, which is dedicated to the display of twentieth-century European and American sculpture. In addition to pieces by Epstein, the collection includes major works by Barbara Hepworth, Henry Moore, Richard Long, Anthony Caro, Eduardo Paolozzi and many other important sculptors.

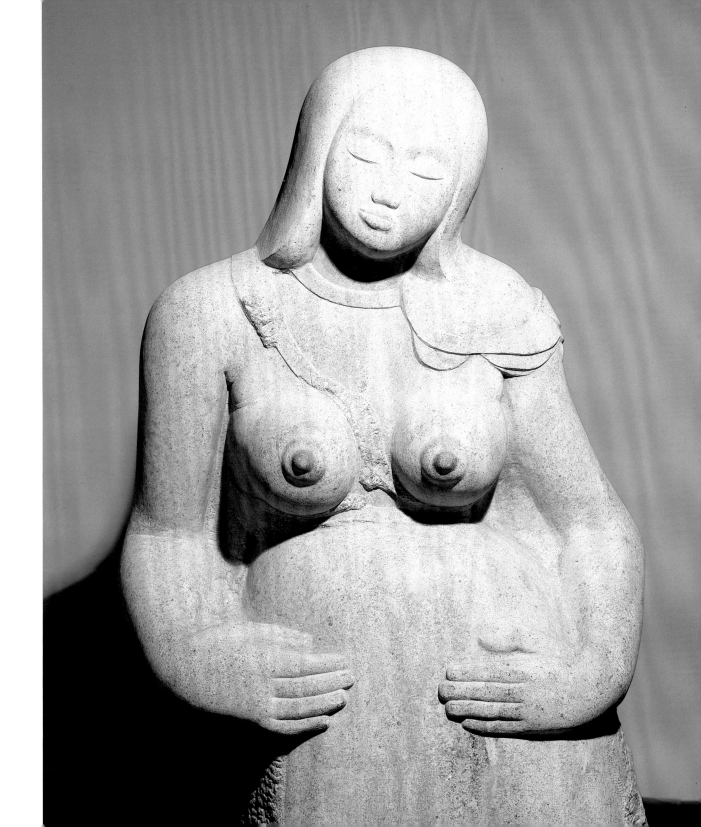

'Mistress Vernon is from court, and lies at Essex House; some say
she hath taken a venew under the girdle and swells upon it, yet she
complains not of foule play but says the Erle of Southampton will justifie
it, and it is bruited, underhand, that he was latelie here fowre days in
great secret, of purpos to marry her and effected it accordingly.'

William Chamberlain, servant of the Earl of Southampton, letter to his friend Carleton,
30 August 1598

Fitzwilliam Museum, Cambridge
Acquired in 1984

ELIZABETH VERNON, COUNTESS OF SOUTHAMPTON, *c.* 1605
Oil on canvas, 188 × 109
English School

Elizabeth Vernon was a maid-of-honour to Queen Elizabeth I, and the mistress of
Shakespeare's patron, the Earl of Southampton. The Queen did not approve of the liaison,
and still less of the marriage, which took place secretly in 1598 when Elizabeth Vernon
became pregnant. This portrait, showing the Countess dressed for the coronation of James I,
hangs in the same gallery as Van Dyck's portrait of *Rachel de Ruvigny, Countess of
Southampton*, the first wife of the Earl of Southampton's heir, giving a clear demonstration
of the dramatic change in court portraiture in one generation. The painting, which came
from the collection of the Earls of Buckingham, was purchased by the Fitzwilliam Museum
in 1984, with the help of the National Art Collections Fund.

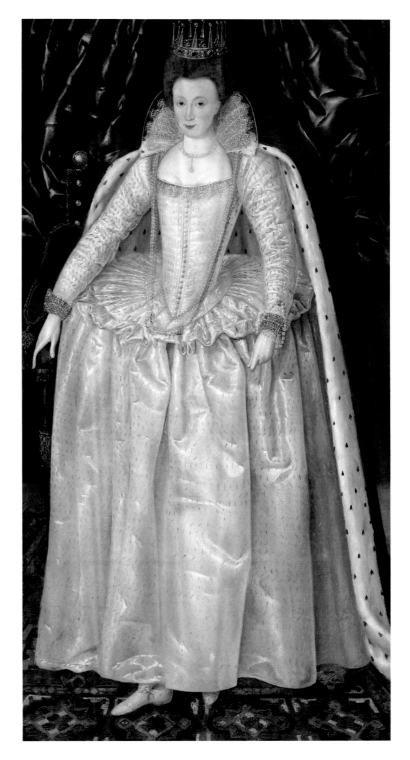

'But, how much beauty of another kind is here, when, on a fair, clear morning, we look, from the summit of a hill, on Florence! See where it lies before us in a sun-lighted valley, bright with the winding Arno, and shut in by swelling hills: its domes, and towers, and palaces, rising from the rich country in a glittering heap – and shining in the sun like gold!

Magnificently stern and sombre are the streets of beautiful Florence; and the strong piles of building make such heaps of shadow, on the ground and in the river, that there is another and a different city of rich forms and fancies, always lying at our feet. Prodigious palaces, constructed for defence, with small distrustful windows heavily barred, and walls of great thickness formed of huge masses of rough stone, frown, in their old sulky state, on every street.'

Charles Dickens, *Pictures from Italy*, 1846

Fitzwilliam Museum, Cambridge
Acquired in 1984

ALLEN SMITH SEATED ABOVE THE ARNO CONTEMPLATING FLORENCE, 1797
Oil on canvas, 69.3 × 89.2
François-Xavier Fabre (1766–1837)

Joseph Allen Smith (1769–1828) was born in South Carolina and spent most of his life in Philadelphia. He visited Europe between 1793 and 1807, travelling to Portugal, Spain, Italy, Ireland, France and Russia. During his stay in Europe he collected engravings, sculpture, gems and medals, which were instrumental in the foundation of the Pennsylvania Academy of Fine Arts. Whilst in Italy, Smith commissioned at least five paintings from Fabre, but the circumstances of this particular commission are not known. Smith himself almost certainly suggested the composition, which derives from Tischbein's celebrated contemporary portrait of Goethe, but is adapted to show a view of Florence.

François-Xavier Fabre, a pupil of Jacques-Louis David, worked briefly in Rome and then in Florence from 1793 to 1824. His works are sadly rare in Britain. The purchase of this painting by the Fitzwilliam Museum in 1984, with the help of the Fund, from the descendants of Louis Clarke, a former director of the museum, was particularly felicitous.

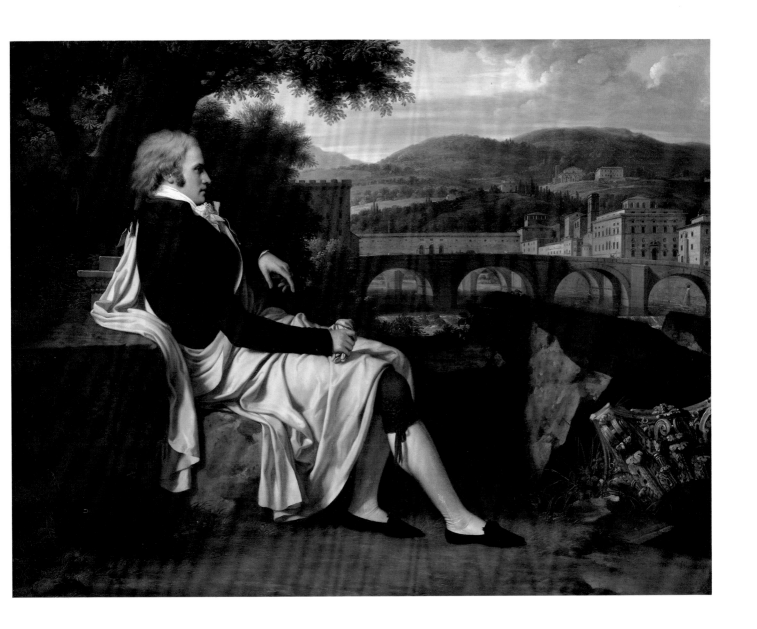

'And when Jesus had cried with a loud voice, he said, Father, into thy hands I commend my spirit: and having said thus, he gave up the ghost.

Now when the centurion saw what was done, he glorified God, saying, Certainly this was a righteous man.

And all the people that came together to that sight, beholding the things which were done, smote their breasts and returned.'

The Bible, Luke 23: 46−8

Manchester City Art Gallery
Acquired in 1984

CRUCIFIXION, 14th century Sienese
Panel with gold ground, 59.7 × 38
Attributed to Duccio (*fl.* 1278−1319)

The traditional attribution of this painting to Duccio has been challenged and fiercely debated only in this century. Scholars have put forward diverse views, but in the absence of scientific proof or documentation, no firm attribution can be made. The painting was purchased in 1863 by the distinguished collector and connoisseur, the Earl of Crawford. His great-grandson was a founder-member and first Chairman of the National Art Collections Fund, and his son was Chairman from 1945−70. It was fitting, therefore, that the Fund should celebrate its eightieth anniversary in 1983 by supporting the appeal organised by Manchester City Art Gallery to secure the painting for a public collection in a part of the country with which the Crawford family had long been connected.

'To become truly immortal a work of art must escape all human limits: logic and common sense will only interfere. But once these barriers are broken, it will enter the regions of childhood vision and dream…

It is most important that we should rid art of all that it has contained of recognizable material *to date; all familiar subjects, all traditional ideas, all popular symbols must be banished forthwith. More important still, we must hold enormous faith in ourselves…'*

Giorgio de Chirico, 'Mystery and Creation', *London Bulletin*, October 1938

Tate Gallery, London
Acquired in 1985

THE UNCERTAINTY OF THE POET, 1913
Oil on canvas, 106 × 94
Giorgio de Chirico (1888–1978)

De Chirico, born in Greece of Italian parents, was the originator of the 'metaphysical' ideas that were crucial to the development of Surrealism. This painting belonged to the Surrealist writer Paul Eluard who, in 1938, tired of the life of a poverty-stricken poet, sold his complete collection of about one hundred objects and paintings to the collector Roland Penrose. Other works from the collection, by Picasso and Max Ernst, are now also in the Tate Gallery. This work was purchased by the gallery in 1985 from the estate of Sir Roland Penrose, under the government's *in lieu* procedure, with additional help from the National Art Collections Fund and other organisations.

georgio de Chirico
M.CM.XII

'If a man whitened his hair, beard, eyebrows, and — were it possible — his eyeballs and lips, and presented himself in this state to those very persons that see him every day, he would hardly be recognized by them ... Hence you can understand how difficult it is to make a portrait, which is all of one color, resemble the sitter.

... Sometimes in order to imitate the original one must put into a marble portrait something that is not in the original...

In order to represent the livid hue that some people have around their eyes we must carve out the place in the marble corresponding to these livid patches so as to render their effect and to make up, so to speak, by this artifice the deficiency of sculpture, which cannot reproduce the colors of things. And yet, the original has not the cavities which we make in the imitation.'

Gianlorenzo Bernini, recorded by Paul Fréart, Sieur de Chantelou, patron of both Bernini and Poussin, 6 June 1665

National Gallery of Scotland, Edinburgh
Acquired in 1986

BUST OF MONSIGNOR CARLO ANTONIO DAL POZZO (1547—1607), *c.* 1620
Marble, 82.5 high (including pedestal)
Gianlorenzo Bernini (1598—1680)

This posthumous bust was commissioned by Carlo Antonio dal Pozzo's nephew Cassiano, who, like his uncle, in whose household he spent his youth, was a distinguished antiquarian. This interest led naturally to his patronage of Poussin, the French painter of classical subjects, who was then living in Rome. Early in the eighteenth century, the bust was purchased from the dal Pozzo Collection by Henry Howard, for his growing sculpture collection at Castle Howard, Yorkshire. The purchase of the bust by the National Gallery of Scotland from the estate of Lord Howard in 1986, with the help of the National Art Collections Fund, reunited it with Poussin's *Mystic Marriage of St Catherine*, which had also once been in the dal Pozzo Collection.

'Some of his last works, which are also in England, are slight things: the colouring is weak, and falls into the lead; nevertheless, his pencil is happy every where; it is light, flowing, mellow, and does not contribute a little to the life, which Vandyck put into every thing he painted. If his Performances are not alike perfect, all in the last degree, they carry with them, however, a great character of spirit, nobleness, grace and truth; insomuch that one may say of him, that excepting Titian only, Vandyck surpasses all the Painters that went before him, or have come after him, in portraits…'

Roger de Piles, *The Art of Painting*, 1699

National Portrait Gallery, London
Acquired in 1987

LORD GEORGE STUART, SEIGNEUR D'AUBIGNY (1618–42), *c.* 1638
Oil on canvas, 218.4 × 133.4
Sir Anthony van Dyck (1599–1641)

Lord George Stuart, son of the Duke of Lennox, was brought up in France and inherited the title of Seigneur d'Aubigny at the age of fourteen. This portrait commemorates his secret marriage in 1638 to Lady Katherine Howard, daughter of the Earl of Suffolk. The match was strongly opposed by her family and by his guardian, the King, and the inscription on the painting – 'Love is stronger than I am' – alludes to his conflicting loyalties. George Stuart is shown in Arcadian dress, with roses and thistles at his feet, symbolising the pleasures and pains of love. The portrait passed down through the family until its sale to a New York gallery in 1986. After an export deferral it was purchased by the National Portrait Gallery, with the help of the National Art Collections Fund, in 1987.

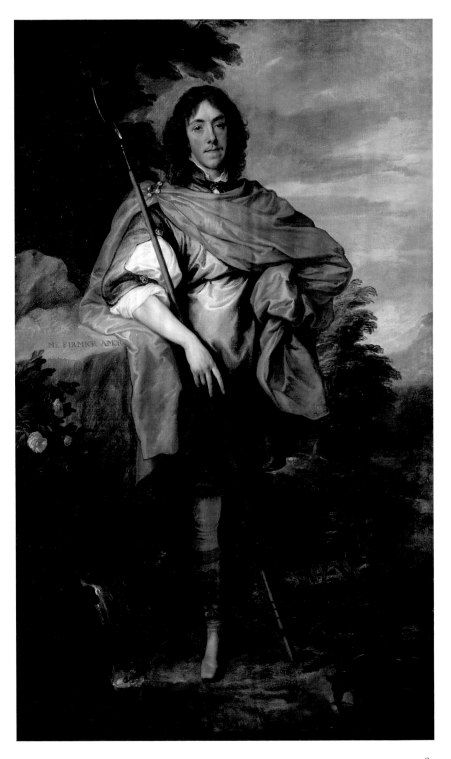

'Make it a habit when you want a cup of tea,
Of calling at the café which overlooks the sea.'

Advertisement for the café on Plymouth Pier, early 1920s

'Beyond a turnstile that snapped like a crocodile's jaws, beyond the slot
machines and the phrenologist, the pier splayed out to its Pavilion's
slightly crumpled pleasure dome...this was the home of touring
concert-parties, usually in pierrot pom-poms and prolific in ballad and
cross-talk...'

J. C. Trewin, *Portrait of Plymouth*, 1973

Plymouth City Museum and Art Gallery
Acquired in 1987

PLYMOUTH PIER, 1923
Oil on canvas, 76.2 × 60.9
Charles Ginner (1878–1952)

Plymouth Pier had a relatively short life. Built between 1884 and 1891, it was the focus
of Plymouth social life in the 1920s – when Ginner painted it – and was destroyed by
bombing in 1941. The pier was, perhaps, always an anomaly in a town noted for its
seafaring connections – Sir Francis Drake, the Pilgrim Fathers and the Eddystone
Lighthouse – rather than as a holiday resort. The City Museum and Art Gallery has a
strong collection of nineteenth- and early twentieth-century paintings, into which this
work by Ginner, a founder-member of the Camden Town Group and subsequently, in
1920, of the New English Art Club, fits neatly. It is also a singular record of a little-
remembered part of Plymouth's past. The painting was purchased by the gallery in 1987,
with the help of the National Art Collections Fund.

Pablo Picasso, in conversation with Christian Zervos, 1934

'The result of using colour in a manner so totally unassociated with grief, for a face in which sorrow is evident in every line, is highly disconcerting. As though the tragedy had arrived with no warning, the red and blue hat is decked with a blue flower. The white handkerchief pressed to her face hides nothing of the agonised grimace on her lips: it serves merely to bleach her cheeks with the colour of death. Her fumbling hands knotted with the pain of her emotion join the teardrops that pour from her eyes. Simultaneously they are her fingers, her handkerchief and the tears that fall like a curtain of rain heralding the storm.'

Sir Roland Penrose, *Picasso His Life and Work*, 1958

Tate Gallery, London
Acquired in 1987

WEEPING WOMAN, 1937
Oil on canvas, 60.8 × 50
Pablo Picasso (1881–1973)

A few months after completing his great mural, *Guernica*, commemorating the devastation of the Basque town by German bombers, Picasso painted a series of works developing the theme of the grief-stricken victim of the massacre. Of these the most striking is *Weeping Woman*. The long hair and dark eyes suggest that Picasso used as a model his then companion, the artist and photographer Dora Maar. The painting was purchased from Picasso by his friend and biographer, Sir Roland Penrose. When Penrose died his son, who inherited the work, loaned it to the Tate Gallery. In 1987 the painting was accepted by the Government *in lieu* of inheritance tax on Sir Roland's estate, and was purchased by the gallery with help from the National Art Collections Fund and other organisations.

'Dear generous master [Canova], I see you now before me. I hear your soft Venetian dialect, and your words of encouraging praise inspiring my efforts and gently correcting my defects – yes – my heart still swells with grateful recollection of you...

 Among the clay sketches which I had been composing was one of a sleeping boy, which Canova said I might execute life size; he often came to correct me as it advanced, and his remarks were of course most invaluable to me. The sleeping shepherd was finished, and I had copied nature pretty close, as the subject admitted the imitation of individual nature.'

John Gibson, notes written for a biography, c. 1838

Walker Art Gallery, Liverpool
Acquired in 1988

THE SLEEPING SHEPHERD BOY, executed c. 1840 from model of 1818–19
Marble, 112 high
John Gibson (1790–1866)

Gibson arrived in Rome in October 1817 with a recommendation to Canova from the artist Henry Fuseli, to whom he had been introduced by his Liverpool patron, William Roscoe. He became Canova's pupil, and the clay model for this sculpture, dating from 1818, was his first life-size figure in Rome. A number of marble versions were made, of which this is probably the second, commissioned before 1841 for Algernon Percy, later Duke of Northumberland. Gibson spent an important part of his early life in Liverpool, and although he never returned there from Rome to settle, he remained close to a circle of Liverpool friends and patrons. The Walker Art Gallery in Liverpool has built up a representative collection of Gibson's work, now displayed in the sculpture gallery which opened shortly after the purchase of this piece was made possible, through the help of the National Art Collections Fund, in 1988.

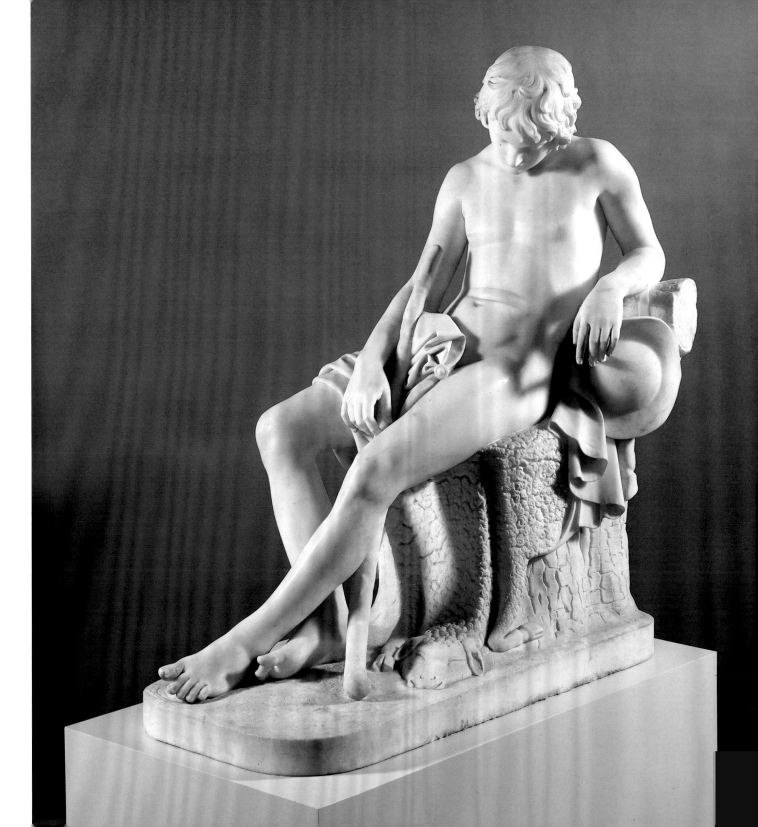

'An art which does not obey fixed and inviolable laws is to true art what a noise is to a musical sound. To paint without being acquainted with these fixed and very severe laws is tantamount to composing a symphony without knowing harmonic relations and the rules of counterpoint.'

Gino Severini, *Ragionamenti sulle arti figurative*, 1936

Pallant House, Chichester
Acquired in 1989

DANSEUSE NO.5, 1915–16
Oil on canvas, 93 × 74
Gino Severini (1883–1966)

A beautiful Queen Anne house in Chichester may seem an unlikely setting for a growing collection of twentieth-century art, including one of only two works by the Futurist painter, Severini, in a British public collection. Walter Hussey, Dean of Chichester Cathedral from 1955 to 1977, gave a large part of his collection of contemporary art – much of which he himself had commissioned – to the city on condition that Pallant House, then used as council offices, should became an art gallery. The gallery was duly established in 1982. Another local collector, Charles Kearley, took a lively interest in the gallery from the start. He bequeathed his collection, of which this work is one of the highlights, to Pallant House, through the National Art Collections Fund, in 1989.

'Joseph Banks Esqr Fellow of this Society, a Gentleman of large fortune, who is well versed in natural history, being Desirous of undertaking the same voyage the Council very earnestly request their Lordships, that in regard to Mr Banks's great personal merit, and for the Advancement of useful knowledge, He also, together with his Suite, being seven persons more, that is, eight persons in all, together with their baggage, be received on board of the Ship, under the Command of Captain Cook.'

Royal Society Council Minutes, requesting the Admiralty to allow Banks to join the *Endeavour*, 9 June 1768

'...Banks...who accompanied him, is aged about 26, possessed of a handsome estate in Lincolnshire; is a Gentleman likewise of great learning and abilities; five years ago he saild to the Labrador Coast, in North America, in search of plants; and from the same laudable thirst after knowledge, he made the above extraordinary voyage.'

London Evening Post, on the return of the *Endeavour*, 8 August 1771

Usher Gallery, Lincoln
Acquired in 1989

PORTRAIT OF SIR JOSEPH BANKS (1743–1820), 1771–2
Oil on canvas, 234 × 160
Benjamin West (1738–1820)

At the age of twenty-one, Joseph Banks inherited vast family estates which included over ten thousand acres around Revesby in Lincolnshire. At Eton and Oxford he had developed an interest in botany, and as a result of his first voyage – to Labrador and Newfoundland – was elected a fellow of the Royal Society and started a Herbarium which was to become the basis of the Natural History Museum's botanical collection. In 1768 he joined Captain James Cook's voyage round the world on the *Endeavour*, and this painting, showing Banks with a Maori cloak, a headdress from Tahiti and a botanical drawing, was commissioned from Benjamin West to record the event. Its purchase by the Usher Gallery in Lincoln in 1989, after the deferral of an export licence, was effected with the help of the National Art Collections Fund, and constitutes a fitting tribute to an influential local man.

'The good will of Mr Rubens, which you have procured for me, has filled me with such happiness and contentment that I shall be indebted to you all my life, for I cannot praise too highly his courtesy, nor extol adequately his virtue and great qualities, both in the domain of profound scholarship and marvellous knowledge of antiquity, and in his rare and skillful conduct of business affairs, as well as his excellence as an artist and the infinite sweetness of his conversation.'

Nicolas Claude Fabri de Peiresc, letter to Caspar Gevartius, who had introduced him to Rubens, 26 February 1622

Ashmolean Museum, Oxford
Acquired in 1989

CAMEO OF THE GLORIFICATION OF GERMANICUS, *c.* 1626
Grisaille heightened in brown on canvas, 100.7 × 80
Sir Peter Paul Rubens (1577–1640)

Rubens painted this cameo as a present for his lifelong friend, the scholar and archaeologist Nicolas Claude Fabri de Peiresc, with whom he shared a passionate interest in classical antiquity. Their idea of collaborating on a book about antique cameos was not realised, but this painting of a cameo, now thought to portray Germanicus taking leave of his father Tiberius and his mother Livia, surrounded by other members of the Imperial family, both alive and (in the lower part) dead, attests to Rubens' familiarity with and feeling for classical sculpture. The painting, in France for many years, was subsequently unrecorded until found by the distinguished Rubens scholar, Christopher Norris, in 1940. On his death in 1989 the work was secured by the Ashmolean Museum, with the help of the Fund, under the government's *in lieu* procedure.

*'The first Earl had been a man of dreams – virtuous and unfortunate.
In the spirit of a crusader he had set out to subdue Ireland; but the
intrigues of the Court, the economy of the Queen, and the savagery of
the kerns had been too much for him, he had effected nothing, and had
died at last a ruined and broken-hearted man.'*

G. Lytton Strachey, *Elizabeth and Essex: A Tragic History*, 1928

Ulster Museum, Belfast
Acquired in 1989

WALTER DEVEREUX, 1st EARL OF ESSEX (1539–76), *c.* 1573
Oil on canvas, 86.4 × 69.8
British School

Walter Devereux was created Earl of Essex in 1572, and appointed Governor of Ulster the
following year. The wand which Devereux holds and the symbols on it indicate that the
work probably commemorates those events. Devereux died of dysentery in 1576, almost
bankrupted by his unsuccessful attempt to colonise Ireland on behalf of Queen Elizabeth.
His son Robert, 2nd Earl of Essex, only nine years old when his father died, was to become
the Queen's favourite for almost a decade before being himself sent to Ireland in 1599 with
orders to suppress the rebellion of the Earl of Tyrone. These connections made the
purchase of the portrait by the Ulster Museum in 1989, with the assistance of the National
Art Collections Fund, especially appropriate.

'I want the people I represent to look as if they belonged to their station, and as if their imaginations could not conceive of their ever being anything else. People and things should always be there with an object. I want to put strongly and completely all that is necessary, for I think things weakly said might as well not be said at all, for they are, as it were, deflowered and spoiled – but I profess the greatest horror for uselessness (however brilliant) and filling up. These things can only weaken a picture.'

Jean-François Millet, letter to his friend, the journalist and art critic
Théophile Thoré, *c.* 1860

National Museum of Wales, Cardiff
Acquired in 1991

SEATED SHEPHERDESS, late 1840s
Oil on panel, 18.6 × 24.3
Jean-François Millet (1814–75)

The bequest of more than two hundred works to the National Museum of Wales by Gwendoline and Margaret Davies forms an important part of the museum's art collection. Millet was a favourite with the sisters, who also bought works by Daumier, Monet, Rodin, Cézanne and Manet. This painting was first owned by the painter and collector Henri Rouart, a close friend of the artist, with whom he often worked. It was purchased by the sisters in 1912 at the Rouart sale in Paris, and was among the few works given to friends and relatives by Margaret Davies shortly before her death in 1963. It is therefore most appropriate that it should have been reunited with the Davies Collection in Cardiff when it was purchased by the National Museum of Wales, with the help of the National Art Collections Fund, in 1991.

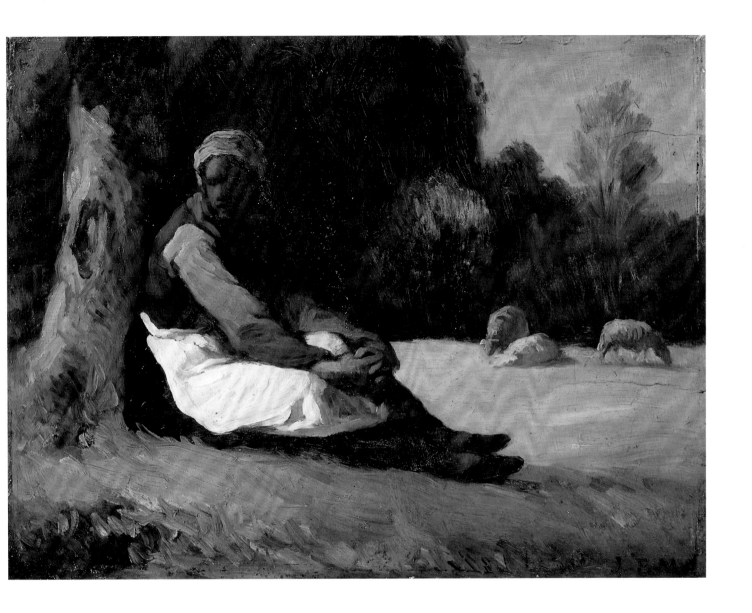

'Last thursday Died ... the Famous Painter Peter Tillemans of Antwerp whose private Virtues secured to him the love of all who knew him, as his publick works have raised him a Monument that will last while Painting has any reputation.'

A friend on Tillemans' death, recorded by George Vertue, Notebooks, c. 1734

'...Considering you have his last Picture his best Picture & many others of his various styles, besides the Connection he had with yr Family you have surely a natural right to one at least of his Productions in every way yr Friends can supply you with.'

Sir Edward Littleton, letter to Dr Cox Macro, Tillemans' patron, 26 September 1757

Castle Museum, Norwich
Acquired in 1991

MASTER EDWARD AND MISS MARY MACRO, c. 1733
Oil on canvas, 117.2 × 88.1
Peter Tillemans (1684–1734)

Dr Cox Macro (1683–1767), scholar, antiquary and avid collector, of Little Haugh Hall, near Bury St Edmunds, was Tillemans' friend and chief patron. Amongst Tillemans' work for the family were portraits – this one shows Dr Cox Macro's two children and their pet dogs – views of the house and interior decorations, including three overdoor paintings of favourite dogs. John Patteson (1755–1833) was a Norwich merchant whose success in business enabled him to satisfy an appetite for collecting, acquired in the course of two Grand Tours. His collection received an early boost when in 1781 he married Elisabeth Staniforth, the heiress to Dr Cox Macro's property and pictures.

In spite of the sale of some works, the Patteson Collection remained largely intact into this century, and was on loan to the Castle Museum, Norwich, for some years prior to the death of the last member of the family in 1989. In 1991 the museum acquired the collection from the executors of the estate under the government's *in lieu* procedure, with the help of the National Art Collections Fund.

'[the intention of the painting is to induce]…a sensation akin to how one's eyes and whole body feel when one steps out of a cool shadow into really hot, direct sunlight… the tautness of the horizontal bands firmly establishes the structure over which our eyes can play, very much as though they were a bow being drawn across the strings of a musical instrument, giving rise to sensation.'

Bridget Riley, conversation with her agent Judy Adam, 16 April 1991

Glasgow Art Gallery and Museum
Acquired in 1991

PUNJAB, 1971
Acrylic on canvas, 145 × 365
Bridget Riley (b. 1931)

Punjab is one of a series of paintings in which Bridget Riley explores the optical relationships set up by the combination of red, blue and green. The title refers to her impression of the colours – particularly reds – used in some schools of Indian miniature painting. Bridget Riley is one of Britain's most innovative abstract painters. Initially influenced by the scientific approach to colour of Seurat and the neo-Impressionists, she has developed her own highly individual style. This work was purchased from the artist by Glasgow City Council in 1991, with a contribution from the Scottish Fund of the National Art Collections Fund.

'Wright is to my thinking far and away the ablest man in our line of work that I have come across in Chicago, perhaps in America. He not only has ideas, but the power of expressing them...'

C. R. Ashbee, Journal, 8 December 1900

' "My God is machinery, and the art of the future will be the expression of the individual artist through the thousand powers of the machine, the machine, doing all that the individual workman cannot do, and the creative artist is the man that controls all this and understands it." '

Frank Lloyd Wright, recorded in C. R. Ashbee, Journal, 8 December 1900

Victoria and Albert Museum, London
Acquired in 1992

HIGH BACKED CHAIR, 1902
Oak with leather seat, 141.4 × 43.3 × 45.8
Frank Lloyd Wright (1867–1959)

Frank Lloyd Wright, one of the most important twentieth-century architects, often assumed responsibility for the design of every aspect of his buildings, including the furniture and fittings. This chair is one of a set made for the house he designed for Ward Willits in Highland Park, Illinois, in 1902. The similarity to contemporary European designs, particularly those of Charles Rennie Mackintosh in Glasgow, and Josef Hoffmann in Vienna, is striking.

The furniture from the Ward Willits house was removed and sold in the 1950s, and examples are now in several museums in the USA. By great good fortune the Victoria and Albert Museum was able to purchase this chair with the help of the National Art Collections Fund in 1992, to incorporate in the Frank Lloyd Wright Gallery, opened in January 1993. The new gallery includes the Kaufmann Office, the only complete interior by the architect on permanent display in Europe, and the Museum's first twentieth-century room, alongside examples of Wright's furniture, metalwork, ceramics, prints, books and graphic designs.

'His drawing has none of the Florentine grace; his color has none of the Venetian charm; but his line and color have a power, a gravity, an inner meaning, which perhaps are found in no other painter.'

Auguste Rodin, *On Art and Artists*, 1911

'It is amazing to think that a man born in Swisserland, and who had never been in Italy, should have such a gusto, and so fine a genius for painting.'

Roger de Piles, *The Art of Painting*, 1699

The National Gallery, London
Acquired in 1992

PORTRAIT OF A LADY WITH A SQUIRREL AND A STARLING, *c.* 1526–8
Oil on wood, 56 × 38.5
Hans Holbein the Younger (1497/8–1543)

This painting is an outstanding example of Holbein's skills as a painter of portraits. It is full of exceptionally beautiful details, from the depiction of the animated, gleaming eye of the squirrel, to the artist's exquisite control of his brush, shown in the undulating black lines that indicate the edges of the sitter's shawl. Other portraits in which Holbein used the half-length formula, with the sitter shown against a blue background with fig branches, are known to have been painted in England, and it is therefore highly probable that this sitter is English. The presence of the squirrel and the starling is unusual. Squirrels were kept as pets in England from the fourteenth century, but the starling is less easily explained. Both may have featured in the sitter's coat of arms, or may symbolically allude to her name.

By 1761 the work was in the collection of the Earl of Cholmondeley. When his descendants decided to sell the painting in 1992, it was secured by The National Gallery by private treaty sale, with the help of the National Art Collections Fund and other organisations. In the gallery it hangs alongside Holbein's masterpiece, *Christina of Denmark, Duchess of Milan* – an early triumph in the Fund's history. This important work was purchased by the Fund in 1909, with the help of a large anonymous donation, and presented to The National Gallery. The name of the donor is never to be revealed, except to the Chairman of the Fund.

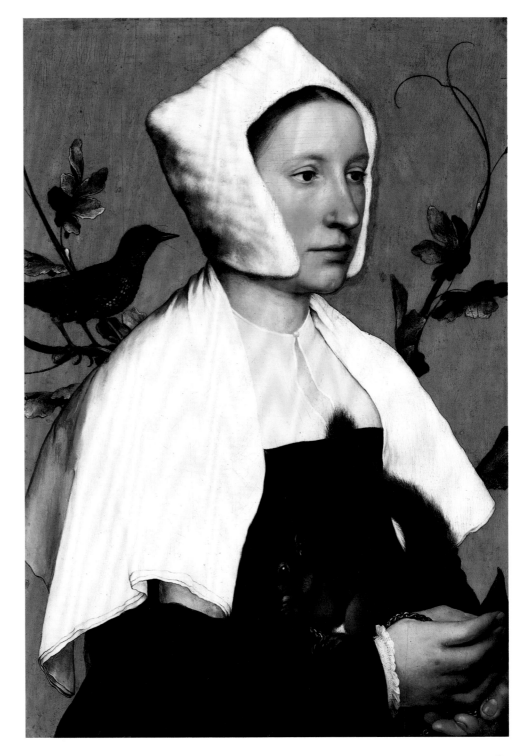

Index of Sources

The National Art Collections Fund gratefully acknowledges the cooperation of copyright holders in granting permission to print relevant extracts. Whilst every effort has been made to trace holders of copyright material, unfortunately this has not always been possible.

8 James Abbott McNeill Whistler, *The World*, 22 May 1878, reprinted *The Gentle Art of Making Enemies*, Heinemann, London, 1919: 126, 127, 128

10 Henry Swinburne, *Travels through Spain in the Years 1775 and 1776*, London, 1787, vol.II: 167

10 *The Times*, 11 March 1914

12 Gaius Suetonius Tranquillus, *The Twelve Caesars*, trans. Robert Graves, Penguin Books Ltd, Harmondsworth, 1957: 94. By permission of A. P. Watt Ltd on behalf of The Trustees of the Robert Graves Copyright Trust.

14 Giorgio Vasari, 'Masaccio', *Lives of the Artists*, trans. George Bull, Penguin Classics, Harmondsworth, 1965, reprinted *Lives of the Artists Volume I*, 1987: 127. © 1965 George Bull. Reproduced by permission of Penguin Books Ltd.

16 *The Bible*, Zachariah 13: 6

16 *The Times*, 1850, quoted in Millais, John Guille, *The Life and Letters of John Everett Millais*, Methuen, London, 1899, vol.I: 75

18 J. Dart, *The History and Antiquities of the Cathedral Church of Canterbury*, London, 1726: 184

20 Amelia B. Edwards, *A Thousand Miles up the Nile*, Longmans, London, 1877, reprinted Century Publishing Company Ltd, London, 1982: 490

22 *The Epic of Gilgamesh*, c. 650 BC. Quoted in *The New Larousse Encyclopedia of Mythology*, Hamlyn, London, 1959: 66

24 Antonio Canova, letter to the Marquis of Lansdowne, 22 February 1821. Quoted in *National Art Collections Fund Annual Report*, 1930: 33

26 William Hazlitt, 'On the Pleasure of Painting', *Table Talk*, 1821. Waller, A. R. and Glover, A. (eds), *The Collected Works of William Hazlitt*, Dent, London, 1903, vol.VI: 8

29 Prince Ludwig of Anhalt-Köhten, *Poetical Itinerary*, 1596. Quoted in Rye, W. B., *England as Seen by Foreigners*, London, 1865: 212

29 Lord Byron, *Don Juan, The Poetical Works of Lord Byron*, Frederick Warne, London and New York, 1890: 609

30 Lorenzo de' Medici, *Selve d'Amore* (c. 1480), *Opere*, ed. A. Simioni, Bari, 1939: 244–5. Quoted in Turner, A. R. (trans.), *The Vision of Landscape in Renaissance Italy*, Princeton University Press, Princeton, 1966: 48–9

32 Henry James, 'John S. Sargent', *Harper's Weekly*, October 1887. Quoted in Wintle, Justin and Kenin, Richard (eds), *The Dictionary of Biographical Quotations*, Routledge, Kegan & Paul, 1978: 653

34 Letter from Joseph Wright of Derby to his sister, *c.* 1772. Quoted in Nicolson, Benedict, *Joseph Wright of Derby, Painter of Light*, Studies in British Art, The Paul Mellon Foundation for British Art, Routledge, Kegan & Paul, London/Pantheon Books, New York, 2 vols, 1968, vol.I: 243. © 1968 Benedict Nicolson

36 *Further Letters of Vincent van Gogh to his Brother 1886–1889*, Constable and Company Ltd, London, 1929: 353

38 *The Public Advertiser* 7 June 1785. Quoted in Webster, Mary, 'Zoffany's painting of Charles Towneley's Library in Park Street', *Burlington Magazine*, July 1964, CVI: 316

40 Harriet de Wint, manuscript memoirs, n.d. Quoted in Armstrong, Walter, *Memoir of Peter de Wint*, Macmillan, London, 1888: 30

42 Charles Ricketts, letters to Katherine Bradley and Edith Cooper, 1898. Quoted in Darracott, Joseph, *The World of Charles Ricketts*, Methuen, New York, 1980: 22–3. © 1980 Cameron & Tayleur (Books) Ltd.

44 William Michael Rossetti, *[Dante Gabriel Rossetti], His family-letters with a memoir*, Ellis & Elvey, London, 1895, vol.II: 177

46 *The Bible*, Exodus 32: 17–19

48 Paul Gauguin, letter to Emile Schuffenecker, March 1888. Quoted in Boyle-Turner, Caroline, *Gauguin and the School of Pont-Aven: Prints and Paintings*, exhibition catalogue, Royal Academy of Arts, London, 1989: 23

50 *The Painters' Mirror*, 1781. Quoted in Archer, Mildred, *India and British Portraiture 1770–1825*, Sotheby Parke Bernet, New York and London, 1979: 94. © 1979 Mildred Archer.

52 Eveline Cruickshanks (ed.), *Memoirs of Louis Philippe, Comte de Ségur*. © The Folio Society, London, 1960: 80, 82, 83

54 John Ruskin, *Academy Notes*, 1856. Cook, E. and Wedderburn, A. (eds), *The Works of John Ruskin*, London, 1904, vol.XIV: 53–4

54 William Powell Frith, *Autobiography and Reminiscences*, 1887, 2nd edn, 1888, Richard Bentley, London, vol.III: 5

56 Thomas Gray, *The Bard. The Poetical Works of Gray and Collins*, ed. Austin Lane Poole, Oxford University Press, London, 1917: 56

58 Joris-Karl Huysmans, 'L'exposition des indépendants en 1881', *L'Art Moderne*, G. Charpentier, Paris, 1883: 225–7. Quoted in Moffett, Charles, *The New Painting: Impressionism 1874–1886*, exhibition catalogue, Fine Arts Museum, San Francisco, and Richard Burton SA, Geneva, 1986: 342

60 Francis Hayman, letter to Sir Edward Littleton, 4 August 1750. Quoted in Allen, Brian, *Francis Hayman*, exhibition catalogue, Yale Center for British Art, Yale and Yale University Press, New Haven and London, 1987: 100. © Yale University Press.

60 Horace Walpole, *Anecdotes of Painting in England, 1762*, London, 1826, vol.II: 325

62 Auguste Rodin, *On Art and Artists*, 1911, trans. Romilly Fedden, Peter Owen, London, 1958: 82

64 Knowler, *The Earl of Strafforde's letters and dispatches*, London, 1739, vol.I: 21. Quoted in Pope-Hennessy, John, *Catalogue of Italian Sculpture in the Victoria and Albert Museum*, HMSO, London, 1964, vol.II: 462

66 Matheo Alemán, *The Life of Guzmán de Alfarache*, trans. James Mabbe, 1623. Quoted in Brigstocke, Hugh, *Catalogue of Italian and Spanish Paintings in the National Gallery of Scotland*, HMSO, Glasgow, 1978: 176

68 R. B. Becket (ed.), *John Constable's Correspondence, II*. © Suffolk Records Society, 1964, vol.VI: 78

70 Henry James, 'Venice', *Century Magazine*, November 1882, XXV, reprinted *Italian Hours*, William Heinemann, London, 1909: 12

72 Joseph Baretti, *A Journey from London to Genoa*, London, 1770, vol.II: 286–7

74 Annie Raine Ellis (ed.), *The Early Diary of Frances Burney, 1768–1778*, George Bell & Sons, London, 1889, vol.I: 113

74 Oliver Goldsmith, in Augustine Birrell (ed.), *Boswell's Life of Johnson*, Archibald Constable and Co., Westminster, 6 vols, 1896, vol. I: 159

76 P. M. C. Kermode, *Manx Crosses*, Bemrose & Son, Liverpool, 1907: 125

78 Virgil, *The Georgics*, trans. C. Day Lewis, Oxford University Press, Oxford, 1983: 102. First published by Jonathan Cape Ltd (1940). Reproduced by permission of the estate of the translator.

80 *The Bible*, Jonah 2: 10 and 4: 6

82 Sir Joshua Reynolds, *Discourses on Art*, Collier Books, New York, 1961: 222

84 Paul Signac, Diary, 1898. Quoted in Russell, John, *Vuillard*, Thames and Hudson Ltd, London, 1971: 95. © 1971 John Russell.

86 Irma A. Richter (ed.), *The Notebooks of Leonardo da Vinci*, Oxford University Press, Oxford, 1952: 222. By permission of Oxford University Press.

88 Thomas Chippendale, letter to Sir Rowland Winn, 19 July 1767. Quoted in Gilbert, Christopher, *The Life and Work of Thomas Chippendale*, Studio Vista and Christies, London, 1978, vol.I: 175. © 1978 Christopher Gilbert.

90 *London Daily Post*, 18 April 1738. Quoted in Coke, David, 'Vauxhall Gardens', *Rococo – Art and Design in Hogarth's England*, exhibition catalogue, Victoria and Albert Museum, London and Trefoil Books Ltd, London, 1984: 76

92 Augustus John, *Chiaroscuro: Fragments of Autobiography*, Jonathan Cape, London, 1952: 256. By permission of David Higham Associates.

94 Sir Charles Cornwallis, *An Account of the Baptism, Life, Death and Funeral of… Frederick Henry, Prince of Wales*, London, 1751: 53

96 Josiah Wedgwood, letter to Richard Bentley, 25 September 1780. Quoted in Tattersall, Bruce, *Stubbs and Wedgwood*, exhibition catalogue, Tate Gallery, London, 1974: 114

98 Giorgio Vasari, 'Titian', *Lives of the Artists*, trans. George Bull, Penguin Classics, Harmondsworth, 1965, reprinted *Lives of the Artists Volume I*, 1987: 458. © 1965 George Bull. Reproduced by permission of Penguin Books Ltd.

100 Henry James, *The Nation*, 1878. Quoted in *The Pre-Raphaelites*, exhibition catalogue, Tate Gallery, London, in association with Allen Lane and Penguin Books Ltd, 1984: 230

102 Roger Fry, 'Retrospect', *Vision and Design*, Chatto & Windus, London, 1920, reprinted Oxford University Press, London, (J. B. Bullen ed.), 1981: 202. By permission of the estate of Roger Fry.

104 *Further Letters of Vincent van Gogh to his Brother, 1886–1889*, Constable and Company Ltd, London, 1929: 27

106 John Flaxman, 'Sketch of Romney's Professional Character' in Hayley, William, *The Life of George Romney*, London, 1809: 306–7

108 *Sheffield and Rotherham Independent*, 23 October 1879. Cook, E. and Wedderburn, A. (eds), *The Works of John Ruskin*, London, 1907, vol.XXX: 311–12

110 Herman Muthesius, *Das englische Haus*, 1904. Quoted in foreword by Eckhart Muthesius, Buchanan, William (ed.), *Mackintosh's Masterwork: The Glasgow School of Art*, Richard Drew, Glasgow, 1989: 9

112 Giovanni Chellini Samminiati, *Libro debitori creditori e ricordanze*, 27 August 1456. Quoted in Avery, C. and Radcliffe, A. (trans.), 'The Chellini Madonna', *Burlington Magazine*, June 1976, CXVIII: 378

114 William Martin Conway (ed.), *Literary Remains of Albrecht Dürer*, Cambridge University Press, Cambridge, 1899: 48

114 Carlo Ridolfi, *Meraviglie dell'Arte*, Venice, 1648, ed. Detlev von Hadeln, Berlin, 1914, vol.I: 72. Quoted in Cannon-Brookes, Peter, *The Cornbury Park Bellini*, Birmingham Museum and Art Gallery, Birmingham, 1977: n.1

116 Giovanni Boccaccio, *The Decameron*, trans. G. H. McWilliam, Penguin Classics, London, 1972: 825–6. © 1972 G. H. McWilliam. Reproduced by permission of Penguin Books Ltd.

118 W. G. Craig (ed.), *The Complete Works of William Shakespeare*, Oxford University Press, Oxford, 1905, reprinted 1954

120 Daniel Defoe, *A Tour through the Whole Island of Great Britain*, abridged and introduced by Pat Rogers, Penguin Classics, Harmondsworth, 1986: 405. © 1971 Pat Rogers. Reproduced by permission of Penguin Books Ltd.

122 Jacobus de Voragine, *The Golden Legend*, trans. Granger Ryan and Helmut Ripperger, Longman Green, London, 1941, reprinted 1948: 705–6

124 Virginia Woolf, *Walter Sickert: a Conversation*, London, Hogarth Press, 1934: 9

124 Jacques-Emile Blanche, *Portraits of a Lifetime 1870–1914*, J. M. Dent & Sons Ltd, London, 1937: 45

126 Sir Edward Thomason, *Memoirs during half a century*, Longman, Brown, Green & Longmans, London, 1845, vol.I: 65

128 Augsburg Passion Play, 15th century. Quoted in Smith, Alistair, *Altdorfer: 'Christ Taking Leave of his Mother'*, exhibition booklet, The National Gallery, London, 1983: 17

128 Ibid.: 5

130 David Sylvester, *Interviews with Francis Bacon*, Thames and Hudson Ltd, London, 1975: 67 and 39–40. © 1975 David Sylvester.

132 Ovid, *Metamorphoses*, trans. Mary M. Innes, Penguin Classics, London, 1955, Book XI: 250. © 1955 Mary M. Innes. Reproduced by permission of Penguin Books Ltd.

134 John Keats 'To John Hamilton Reynolds, Esq.', 25 March 1818. Quoted in Wilson, Michael, *Acquisition in Focus: 'The Enchanted Castle'*, exhibition booklet, The National Gallery, London, 1982: 15

136 Dr Gustav Waagen, *Treasures of Art in Great Britain*, 1854, vol.III: 243, 250

138 Max Beckmann, *Breife im Kriege*, Albert Langen and Georg Müller, Munich, 1955: 38

138 Max Beckmann, *On My Painting*, 1938. Quoted in Goldwater, Robert, and Treves, Marco (eds), *Artists on Art*, John Murray (Publishers) Ltd., London, 1976, reprinted 1990: 448

140 George Vertue, Notebooks, 1749 (vol.III). Walpole Society, 1933–4, XXII: 151

142 William Burges, 'Furniture', *Art Applied to Industry*, 1865. Quoted in Wainwright, Clive, 'Pre-Raphaelite Furniture', *The Strange Genius of William Burges*, exhibition catalogue. © National Museum of Wales, Cardiff, 1981: 67

144 C. A. du Fresnoy, *The Art of Painting*, 1668, trans. John Dryden, London, 1750 (3rd edn): 31

146 Edward Conze (ed.), *Buddhist Texts*, Bruno Cassirer, Oxford, 1954: 131

148 Sir Richard Redgrave, *A Century of Painters of the English School*, 1866: 443. Quoted in Greenacre, Francis, *Francis Danby 1793–1861*, exhibition catalogue, Tate Gallery, London, 1988: 95

148 J. Hogarth, letter, *Art Journal*, 1 October 1860: 317

150 Sir Jacob Epstein, *Let there be sculpture: An Autobiography*, Michael Joseph Limited, London, 1940: 32

152 William Chamberlain, letter to his friend Carleton, 30 August 1598. Quoted in Stopes, C. C., *The Life of Henry, Third Earl of Southampton*, Cambridge University Press, Cambridge, 1922: 122–3

154 Charles Dickens, *Pictures from Italy*, 1846, reprinted *American Notes and Pictures from Italy*, Oxford University Press, London, 1957: 429–30

156 *The Bible*, Luke 23: 46–8

158 Giorgio de Chirico, 'Mystery and Creation', *London Bulletin*, October 1938, 6: 14. Quoted in Goldwater, Robert and Treves, Marco (eds), *Artists on Art*, John Murray (Publishers) Ltd., London, 1976, reprinted 1990: 439–40

160 Gianlorenzo Bernini, recorded by Paul Fréart, Sieur de Chantelou, 6 June 1665. Quoted in Lalanne, L., 'Journal du Voyage du Cavalier Bernin', *Gazette des Beaux-Arts*, 1877, 1: 186. See Goldwater, Robert and Treves, Marco (eds), *Artists on Art* (trans.), John Murray (Publishers) Ltd., London, 1976, reprinted 1990: 134

162 Roger de Piles, *The Art of Painting*, 1699, trans. B. Buckeridge, London, 1706, 3rd edn (1750): 269–70

164 J. C. Trewin, *Portrait of Plymouth*, Robert Hale Ltd, London, 1973: 109

166 Christian Zervos, 'Conversation avec Picasso', *Cahiers d'Art*, Paris, 1935, X: 174

166 Sir Roland Penrose, *Picasso His Life and Work*, Gollancz, London, 1958, 3rd edn (1981): 314–15. © The estate of Sir Roland Penrose.

168 John Gibson, notes written for a biography, 1838. Quoted in Matthews, T., *The Biography of John Gibson, R. A. Sculptor, Rome*, Heinemann, London, 1911: 45, 49

170 Gino Severini, *Ragionamenti sulle arti figurative*, Milan, 1936. Quoted in Goldwater, Robert and Treves, Marco (eds), *Artists on Art*, John Murray (Publishers) Ltd., London, 1976, reprinted 1990: 438

172 Royal Society Council Minutes, 9 June 1768. Quoted in Beaglehole, J. C., *The Life of Captain James Cook*, London, A. & C. Black (Publishers) Ltd, 1974: 144

172 *London Evening Post*, 8 August 1771. Quoted in Beaglehole, J. C. (ed.), *The Voyage of the Endeavour 1768–1771*, Cambridge University Press, Cambridge, for the Hakluyt Society, 1955: 651

174 Max Rooses and Charles Ruelens, *Correspondance de Rubens et documents épistolaires concernant sa vie et ses oeuvres*, Antwerp, 1887–1909, vol.II: 337. Quoted in Baudouin, Frans, *Peter Paul Rubens*, trans. E. Callander. © Bracken Books, London, 1989: 331

176 G. Lytton Strachey, *Elizabeth and Essex: A Tragic History*, Chatto & Windus, London, 1928. Reprinted 1932: 2–3

178 Alfred Sensier, *Jean-François Millet*, trans. Helena de Kay, Macmillan & Co., London, 1881: 142

180 George Vertue, Notebooks, *c.* 1734, vol.III: 73. Quoted in Raines, Robert, 'Peter Tillemans, Life and Work, with a list of representative Paintings', Walpole Society, 1978–80, XXXVII: 26

180 Ibid.: 23

182 Bridget Riley, conversation with her agent Judy Adam, 16 April 1991. Quoted in *National Art Collections Fund Review*, 1992: 151

184 C. R. Ashbee, Journal, 8 December 1900. Quoted in Anscombe, Isabelle and Gere, Charlotte, *Arts and Crafts in Britain and America*. © Academy Editions, London, 1978: 35

184 Ibid.: 36

186 Auguste Rodin, *On Art and Artists*, 1911, trans. Romilly Fedden, Peter Owen, London, 1958: 118

186 Roger de Piles, *The Art of Painting*, 1699, trans. B. Buckeridge, London, 1706, 3rd edn (1750): 234

Index of Galleries and Works

Photographic credits

Aberdeen Art Gallery and Museum
Bedford, Cecil Higgins Art Gallery and Museum
Belfast, The Trustees of the Ulster Museum
Birmingham Museums and Art Gallery
Bournemouth, Russell-Cotes Art Gallery and Museum
Bradford Art Galleries and Museums Services
Bristol City Museum and Art Gallery
Burnley, Borough Council Art Gallery and Museums
Cambridge, Fitzwilliam Museum
Cardiff, National Museum of Wales
Chichester, Pallant House
Derby Museum and Art Gallery
Edinburgh, National Galleries of Scotland
Exeter, Royal Albert Memorial Museum
Glasgow Museums: Burrell Collection
Glasgow Museums: Art Gallery and Museum
Glasgow, Hunterian Art Gallery, University of Glasgow, Mackintosh Collection
Harrogate, Mercer Gallery
Hastings Museum and Art Gallery
Hove Museum and Art Gallery
Ipswich Borough Council Museums and Galleries
Isle of Man, Manx National Heritage, Manx Museum, Douglas
Kendal, Abbot Hall Art Gallery and Museum
Leeds City Art Galleries
Lincoln, Usher Gallery
Liverpool, National Museums and Galleries on Merseyside
London, British Museum
London, The National Gallery
London, National Portrait Gallery
London, Tate Gallery
London, Victoria and Albert Museum
Manchester City Art Galleries
Manchester, Whitworth Art Gallery, University of Manchester
Newcastle upon Tyne, Laing Art Gallery
Norwich, Castle Museum
Oxford, Ashmolean Museum
Plymouth City Museum and Art Gallery
Southampton City Art Gallery
York City Art Gallery

© ADAGP, Paris and DACS, London 1993. Gino Severini (Chichester, Pallant House)
© Woodmansterne. George Romney (Kendal, Abbot Hall Art Gallery and Museum)
© DACS 1993. Max Beckmann, Giorgio de Chirico and Pablo Picasso (London, Tate Gallery)

General Index

Figures in italics refer to illustrations

National Art Collections Fund

Britain's museums and galleries house works of art which enrich the lives of millions. But lack of funding makes it difficult or even impossible for them to acquire new works – unless they are given help. Today the problem is more acute than it has ever been.

The National Art Collections Fund is Britain's leading charity in its field, helping museums throughout the country buy works of art to augment their collections. Founded in 1903, our success has secured for the nation many thousand works of art, including some of the most important and best-loved in Britain. Our first great triumph came when we bought Velázquez's *Rokeby Venus* for The National Gallery in 1906 for £45,000, then nine times the gallery's annual purchase grant. Because of our work there are Monets in the Tate Gallery, Canalettos in Birmingham and Pre-Raphaelites in Bournemouth, as well as four hundred teapots in Norwich, the legs of Henry VIII's armour in the Royal Armoury and a Charles Rennie Mackintosh bedroom in Glasgow.

The National Art Collections Fund is an independent charity, and receives no government funding. We rely on members' subscriptions, bequests and donations to continue our work. Our role is becoming ever more vital as art prices soar and our museums are unable to keep pace. We are also a powerful voice urging the government to give better funding and a higher priority to the arts.

The National Art Collections Fund has over 36,000 members. The benefits of membership include free admission to all art museums and galleries in Britain, reduced admission to major exhibitions, and *The Art Quarterly*, our lively and informed magazine, mailed directly four times a year. We also produce a beautifully illustrated annual *Review* of our work, cataloguing everything we have helped to buy that year, which is also free to members. And, because our investments more than cover our running costs, every penny our members give us goes to buying works of art.

Join us, and help secure Britain's art heritage.

National Art Collections Fund
20 John Islip Street
London SW1P 4JX

From early 1994
7 Cromwell Place
London SW7 2JN